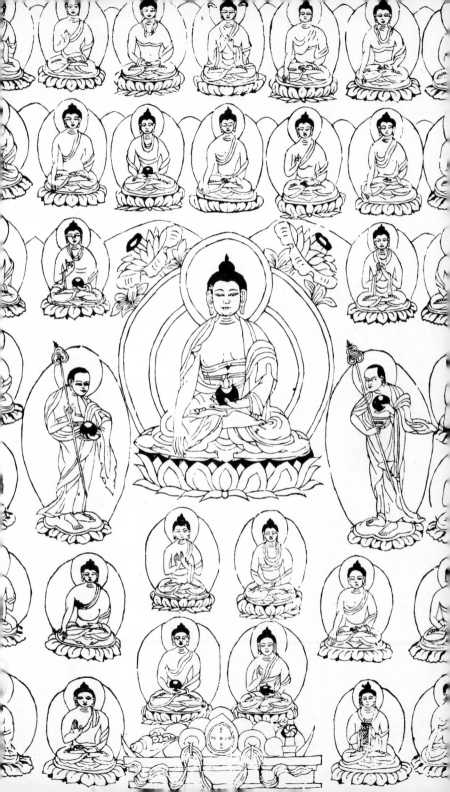

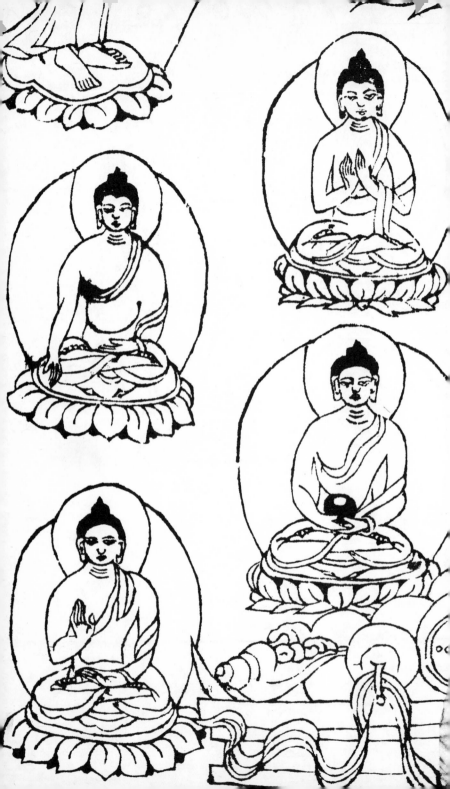

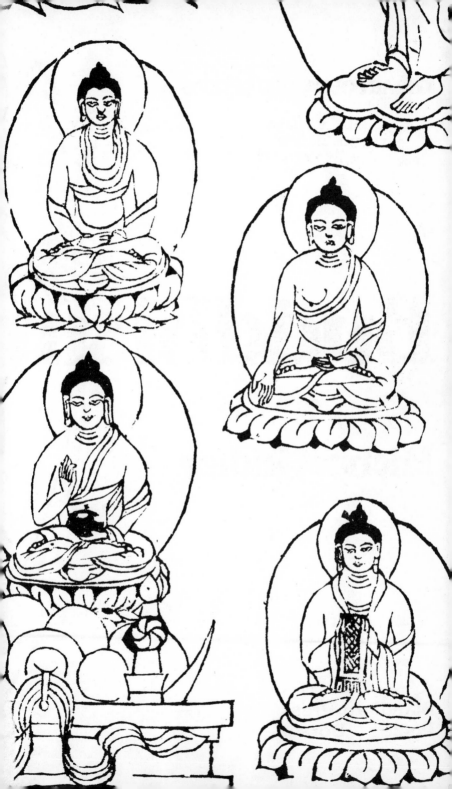

THE ART OF WORLD RELIGIONS

Buddhism

Michael Ridley

Blandford Press
Poole · Dorset

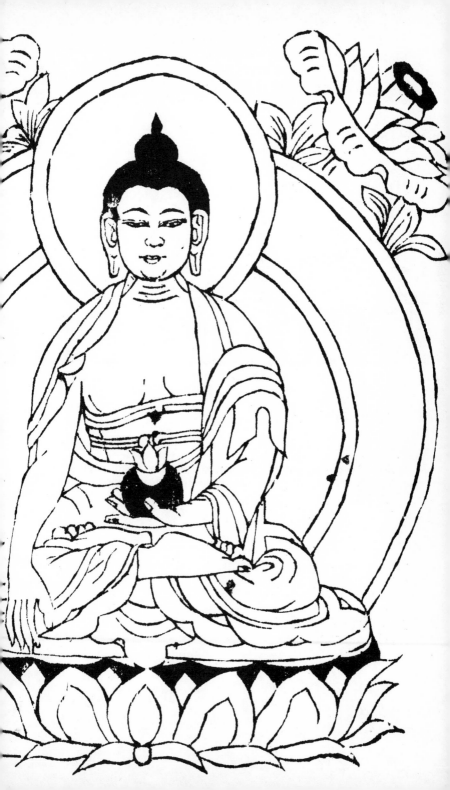

Published 1978 by Blandford Press,
Link House, West Street, Poole, Dorset, BH15 1LL

Printed and bound in Great Britain by
Butler & Tanner Ltd, Frome and London,

ISBN 0 7137 0886 7

CONTENTS

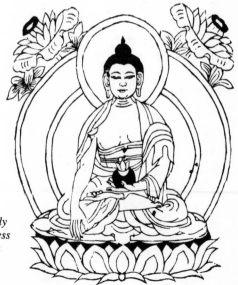

*This book is respectfully
dedicated to His Holiness
The 14th Dalai Lama*

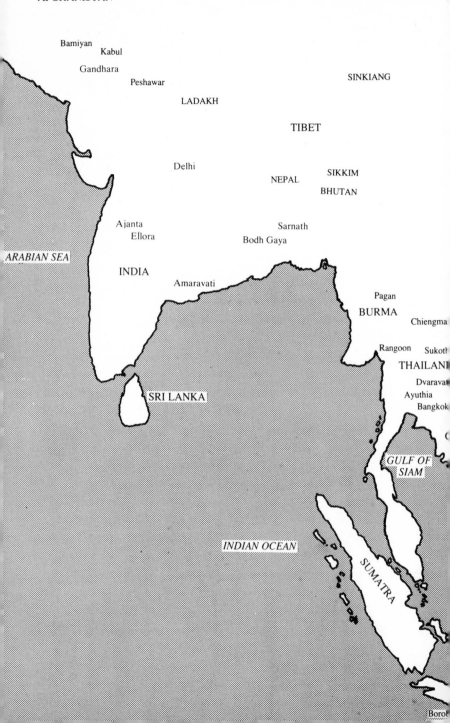

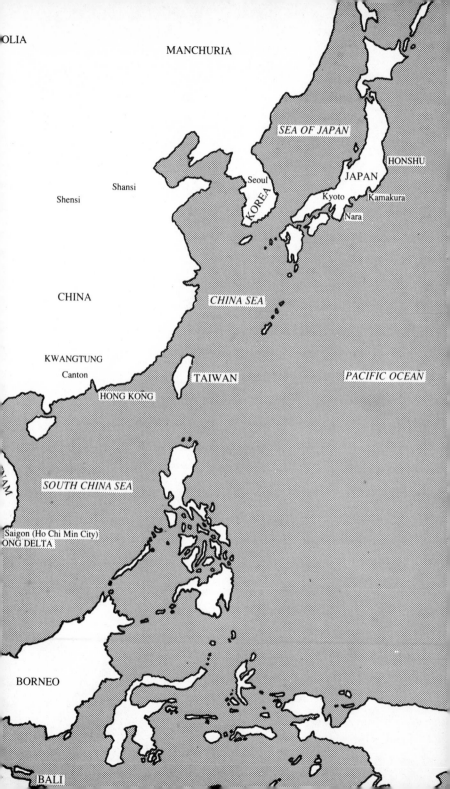

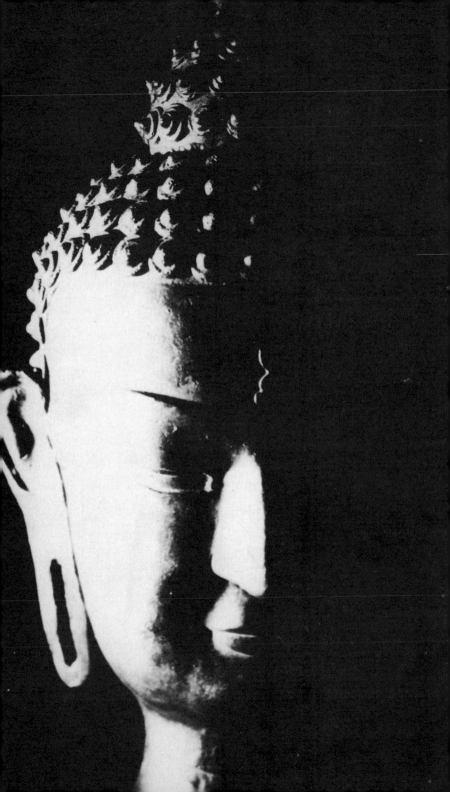

1 BUDDHISM: THE MIDDLE WAY

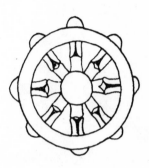

Silhouetted against a full July moon, five figures sat listening to a young man seated beneath a tree. The man's face, which was lit up by the moonlight, had an air of detached spirituality and complete understanding. The five listened intently to the speaker's every word, the only other sound that filled the air was the high drone of the crickets.

This seemingly unmomentous scene was, in fact, an event of world importance, for it was the first sermon on the principles of a philosophy which was to become known as Buddhism. The year was 528 B.C., the place, the Deer Park at Isipatana (present-day Sarnath), near Varanasi in India, the speaker Siddhartha Gautama of the tribe of the Sakyas.

The events leading up to this momentous occasion are extremely important, not only for the understanding of the teachings of Buddhism, but also for the understanding of the art which expresses these teachings—art which spans half the world.

The story of Buddhism starts in the year 563 B.C., at the court of Suddhodana, ruler of the Sakyas. Legend has it that at the birth of a son to his wife, Mahamaya, he was visited according to custom by a number of astrologers, sages and wise men, who attempted to predict the child's fortune. One such sage, a master of 'Body Reading', announced that the child was not destined to become a great ruler, but would instead obtain 'Enlightenment' and Buddhahood. This

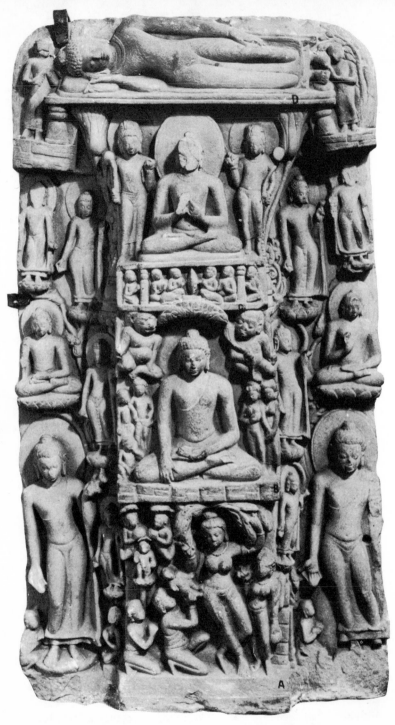

Scenes from the life of the Buddha. Sculpture from Sarnath, India. c. 6th century A.D.

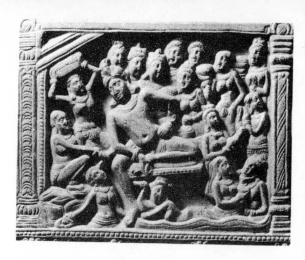

Prince Siddhartha enjoying the pleasures of the palace. Sculpture from Nagarjunakonda, Andhra Pradesh, India. 2nd–3rd century A.D.

worried Suddhodana, who had other plans for the child. So, in order to allay his fears, he summoned eight other Brahmins, who were also skilled in the same clairvoyant art. They concurred with the original prediction, but seven of them added that the child could also become a great emperor, the former depending upon the child forsaking the world, the other his remaining in it. The eighth Brahmin insisted that there was only one course open; that of Buddhahood. This prediction was that of Kondanna, one of the five who sat before the Buddha in the Deer Park at Sarnath, listening to the Enlightened One's first teaching. So sure was he of his own prediction, that on leaving the court he had set out for the mountains and jungles, leading a life of an aesthetic to await the Buddha's coming.

Suddhodana, greatly worried and stunned by the prediction, took every care to shield Siddhartha from witnessing the four signs which Kondanna had said would trigger his son's realisation of the reality of life and which would lead him to renounce the world in search of truth. In spite of the this protection, the inevitable happened. After years of seclusion, Siddhartha gradually witnessed the four signs— an old man, a sick man, a dead man and a holy man; old age, sickness and death, and the attempt of the aesthetic to seek a meaning and solution to it all.

Soon after seeing these signs, the once carefree prince was so moved and troubled that he left the court and all its pleasures, his wife and child, and entered the real world in search of truth. The truth, however, was not easily found, for he went from holy man to holy man, seeking the answer which was not there. He tried everything, including self-mortification. In this, he was in the company of five other aesthetics, one of whom was Kondanna. After six years,

he collapsed. Being nursed back to health by a shepherd, Siddhartha suddenly realised that fasting and self-torture did not lead to Enlightenment, and so he decided to give up this path. This disgusted his companions so much that they left him. It was after this, in his great meditation beneath the Bodhi tree, that he obtained Enlightenment, *Nirvana*, complete freedom from re-birth. The reasons for suffering and the key to release were now clear to him. It was this message that he gave to his companions who sat before him at Sarnath.

They had heard that he had obtained *Nirvana* and had at first gone to the Deer Park to scoff and taunt him, but on seeing his aura of calm and understanding, realised that a great change had taken place, and that he had indeed found Enlightenment.

It is extremely difficult to explain an abstract concept with concrete words, for words can only surround an idea, they can never truly express an idea that can only be perceived in spite of the words that attempt to express it. It is through realising the unspoken reality, which can equally well be symbolic, and expressed by sound, smell or sight, that an abstract idea may be conveyed. Thus, the expression of Buddhist thought, especially in English, such a concrete language, can only describe the outer shell and not the inner meaning. This being said, the concrete message of the Buddha that he preached that July evening can be expressed as the Middle Way.

In his life, the Buddha experienced the two extremes of living—one of pampering the body, the other of denying the body, both in excess. Neither of these help the spirit. His teaching of the Middle Way was, in effect, a natural reaction to both the paths he had previously trodden, furthermore, his mind had, in the beginning, been influenced by the Brahmanic culture into which he had been born. It therefore can be said that the Buddha himself was inevitable, and his teachings, non-reactionable as they were, a logical progression of the then understood principles of philosophy and religion. Thus, Buddhism in its infancy was not regarded as heretic, and its followers were not persecuted. In spite of this, the Buddha's teachings are, in fact, revolutionary and their implications are not confined to the boundaries of time or geography. His teachings are the fundamental truth of life and human nature and therefore can cross time, race and culture. It is this timelessness of Buddhism that has made its message as relevant and meaningful to the people of the 20th century as it was to those of the 6th century B.C.

The Middle Way is, in essence, extremely simple, but it contains a truth of far-reaching significance. The Buddha, addressing his com-

Early Chinese painting showing Sakyamuni, preaching on the Vulture Peak. c. 8th century A.D.

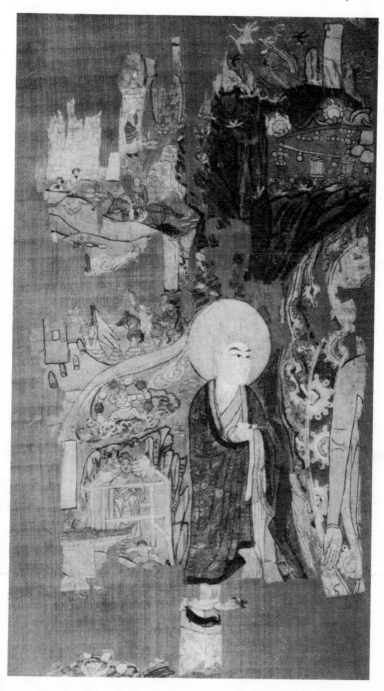

panions in the Deer Park, knew this. He knew too, that they had seen what he had seen, and practised what he had practised. They had done this, yet they had failed to perceive the fundamental truth. His first sermon was therefore a sharing of his insight.

In his sermon he said that there were two extremes of life, one was over-indulgence and attachment to the luxuries of life, of wealth, food, drink, and the flesh, while the other was the masochistic indulgence in self-denial. Both were to be avoided, in their place one should strive for the middle path. This, he said, leads to spiritual calmness, and an insight into life, leading to higher knowledge, Enlightenment and ultimately *Nirvana*.

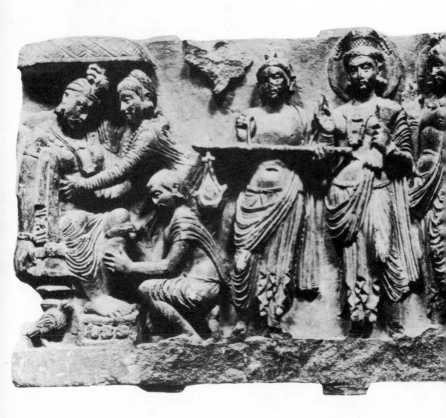

Stone sculpture depicting the story of Sarvanada. Gandhara, 1st cent A.D.

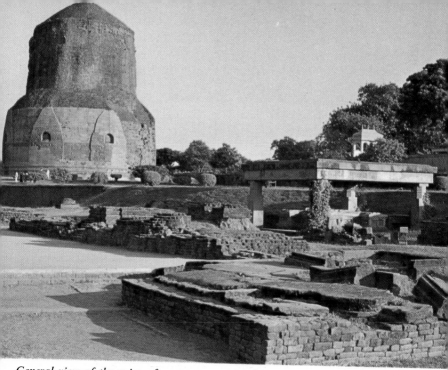

General view of the ruins of a monastery erected on the site of the Deer Park at Sarnath where the Buddha preached his first sermon.

Detail of the Gupta stupa at Sarnath. 5th century A.D.

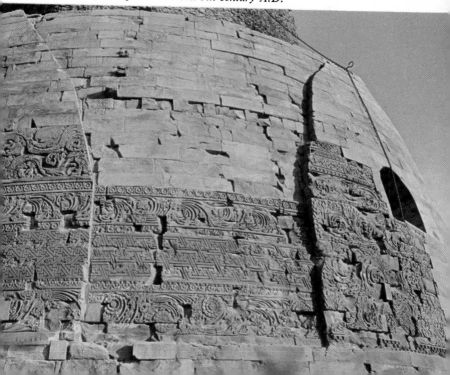

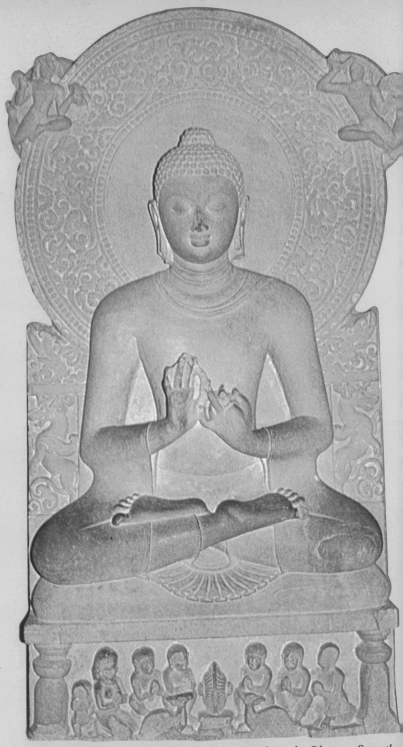

The now famous sculpture of the Buddha preaching the Dharma. Sarnath, Gupta period, 5th century A.D.

The Middle Way consists of understanding the Four Holy Truths and the Noble Eight-fold Path.

The Four Holy Truths may be expressed as follows:

1) Existence is unhappiness,
2) Unhappiness is caused by desire and selfishness,
3) Desire and craving can be overcome by
4) Following the Eight-fold Path.

The steps of the Eight-fold Path are—

1) Right Understanding,
2) Right Purpose,
3) Right Speech,
4) Right Behaviour,
5) Right Vocation,
6) Right Effort,
7) Right Alertness,
8) Right Concentration.

The Enlightened One explained the truths and the path thus. All life is painful; birth, sickness, old age, death, sorrow, dejection and despair, all are painful. Disappointment at not having or doing what one wants is painful. All existence is painful and inevitably unhappy.

Pain, he said, was caused by desire, a craving for life, or even for death, pleasure, lust, possessions, for good health, or happiness, in fact, a craving for anything and everything. Even the desire not to crave was desire and thus would lead to unhappiness.

The Third Holy Truth, he said, is that certainty that all pain and unhappiness could only cease entirely when complete non-attachment to life, possessions, friends and loved-ones was achieved. In effect, a complete release and abandonment. Attachments should be replaced by genuine compassion.

The Fourth Holy Truth is the path to the cessation of pain and unhappiness, a formula for life, the Eight-fold Path.

The steps along the Path were essential, for without right understanding of the puzzle of life and the aspiration and purpose to seek this answer, nothing could be achieved, and right speech, conduct and vocation were a necessary foundation of moral conduct on which to build, while right effort, alertness and concentration were necessary to avoid distractions and temptations to ensure that the traveller along the Path reached its joyful end with compassion and love for all creatures, however low, Enlightenment, non-duality, and liberation.

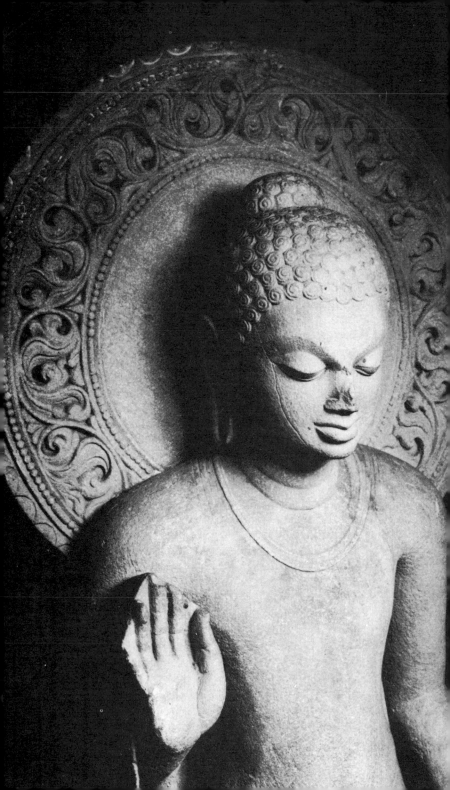

The astounding simplicity of this teaching has often led to its real meaning being misunderstood and under-rated, but its significance in relation to truth and life is profound, and has lasted longer than any religious teaching in the world. A view of life that has been expressed in a world of beauty and art.

This famous sermon in the Deer Park is known as the 'Setting in motion of the Wheel of Existence'. It is also known as the 'Wheel of the Doctrine' and the 'Wheel of Law', for the Buddha compared the spokes of the wheel to the rails of pure conduct, justice being the oneness of their length, wisdom the rim, while the axle of truth is attached to the hub, which is modesty and thoughtfulness. His explanation of the doctrine was based on this conception of a metaphorical wheel. The wheel became an important symbol in the Buddhist art of many countries.

Opposite: *Superb stone sculpture of the Buddha, from Sarnath. The flower of Gupta art.*
Below: *Gandhara stone sculpture of the Parinirvana, the death of Buddha. 2nd century A.D.*

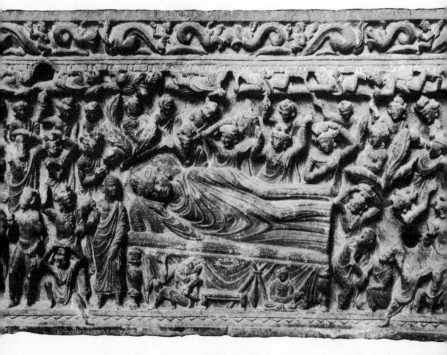

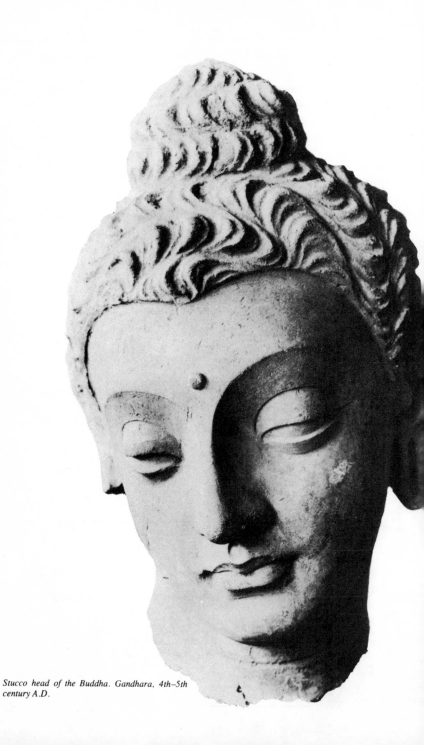

Stucco head of the Buddha. Gandhara, 4th–5th century A.D.

2 HINAYANA, MAHAYANA AND VAJRAYANA

To those not acquainted with the philosophy, Buddhism can be extremely confusing. This is because of the mass of writings and doctrines that have grown up in the 2,500 years following the Buddha's birth. These often appear to be conflicting, but they are not. The Middle Way is a wide Path, with many side roads, which lead to the same destination. Buddhism itself is not entirely original, it grew naturally out of the Brahmanic Vedic philosophies which preceded it. Early Brahmanic philosophies had in the Vedic *Upanishads* woven a view of life in which physical existence was finite, but the spiritual self (*Atman*) was infinite, until its ultimate unification with Brahman, the omnipotent, all pervading force. In other words, the theory of reincarnation had already been expounded at the time of the birth of the Buddha. So, too, had the practise of foresaking the world in order to seek out philosophical and religious truths. Thus, the Buddha was influenced by accepted views of existence and followed the natural path to seek his answer. In this way, Brahmanism was the natural springboard for Buddhism.

Buddha himself, however, was not considered a heretic, but was regarded as working within the framework of existing religious philosophies. In this way, there was no violent reaction against him or his followers, for there was nothing to react against. It was a logical internal revolution.

However, it was a revolution for only part of the religion, for the two philosophies soon went their separate ways. Brahmanism continued, providing the basis of later Hinduism, while Buddhism developed in its own right, eventually declining in India, the place of its birth but flourishing in many other countries in Asia. Many of its principles and values influenced Brahmanic thought and were eventually incorporated into Hinduism. Hinduism can therefore be said to be in part Buddhistic Brahmanism.

Although Buddhism at its birth was close to Brahmanism, they were fundamentally different, for Brahmanism, steeped in ritual, had grown out of early Aryan beliefs and was based on the worship, with sacrifice, of the gods of creation and nature. Buddhism, on the other hand, was on a much higher level, it was an overall philosophy of life. It was by its very nature intellectual, although the message was of the utmost simplicity.

On his death-bed, the Master reiterated his main teachings and message of the forty years following his Enlightenment. Within a few days of his cremation, a large gathering was held, at which the disciples exchanged all the anecdotes and teachings which they had heard during his lifetime. Ananda, his cousin and principal disciple, recited the *Sutta-pitaka*, a large collection of sermons on doctrines and ethics, while other disciples recollected other teachings, including the *Vinaya-pitaka*, or the rules of the order which the Buddha had given them. This was, in effect, the first Great Council. The second Buddhist Council was held one hundred years later at Vaisali. At this meeting, the various philosophical and religious interpretations of the Buddha's original teachings were debated, resulting in a schism between various sections. The order broke into the orthodox Sthaviravadins (Theravadi: Pali) meaning the Followers or Believers in the Teachings of the Elders, and the Mahasanghikas, or Members of the Great Community.

The differences, at first, were small, but soon grew, and at the third Great Council, held at Pataliputra, during the reign of the Emperor Asoka, the Sthaviravadin was established as the orthodox doctrine and a number of so-called 'heretics' expelled.

Buddhist doctrine continued to change and the final schism occurred at the fourth Great Council held in Kashmir, under the patronage of the Kushan emperor, Kanishka (A.D. 78–103), some time during the first or second century A.D. The division between the Greater and Lesser Vehicles, the Mahayana and Hinayana respectively, was formally established at this Council. Division, of

course, had been evident much earlier, but had been aired at the Council of Pataliputra. Heated debate had continued with doctrinal disputes. In effect, the real divisions between the Mahayana and Hinayana schools continued to grow.

But what is the difference between Mahayana and Hinayana? Hinayana is often regarded as the purest form of Buddhism. Having said this, we should remember that the Hinayana that we know today is probably as far removed from the original teachings of Buddha as are the teachings of Mahayana. Both have some aspect that can be traced back to the original teachings. In the beginning, there were several sects of Hinayana Buddhism but the only one that survives today and is common throughout Sri Lanka, Burma and South East Asia, is the Sthaviravadin, generally known as Stharavada.

Buddhism is a non-religion, and denies not only the existence of God, but also, in Hinayana, the divinity of the Buddha. The Buddha himself is regarded as a man, a teacher, and not a god. Thus, although images of the Buddha are included in Hinayana temples, he is portrayed simply as a symbol, or signpost to his teachings. There is no division in a Buddhist temple between an area of god and an area of man, it is all the domain of man. Hinayana teaches reliance on self; in other words, that one should not expect miraculous intercedence from some almighty deity in heaven, but rely on one's own efforts and conduct—there is no hope of external help, but only of the help within. This is interesting, as it contrasts with the Buddhist's denial of individuality and selfhood.

Festival at the Temple of the Tooth, Kandy, Sri Lanka.

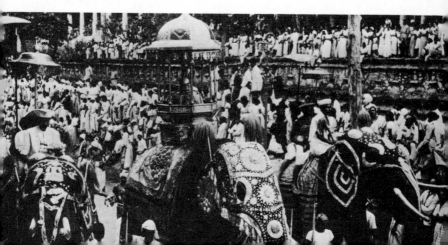

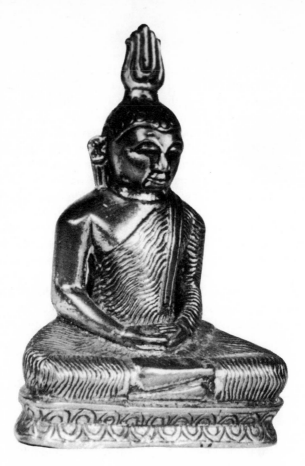

Miniature gilt-bronze figure of the Buddha. Sri Lanka, 17th–18th century.

The fundamental teaching of Hinayana (and also Mahayana) is based on the sermon at Varanasi (Benares)—the Four Holy Truths and the Eight-fold Path. The Hinayana scriptures also teach a passage which has become known as the 'Chain of Dependent Origination'. This is a vague and ambiguous passage which practically no-one fully understands, but which the kernel can be expressed in the following way, that, out of ignorance comes imagination, from which follows self-consciousness, out of which comes name and form, which is corporal existence, and then the six senses, the sixth of which is thought. From this comes contact, then feelings and emotion, then craving and attachment and becoming from which comes re-birth, and all the ills that are attached to the flesh. Perhaps the meaning of this passage is that life is full of sorrow and suffering, that life is transient and soulless.

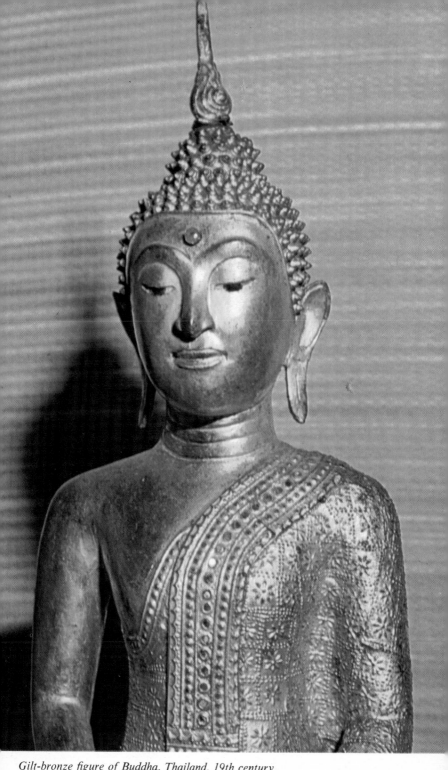

Gilt-bronze figure of Buddha. Thailand, 19th century.

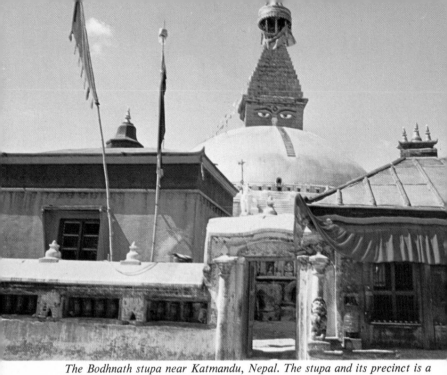

The Bodhnath stupa near Katmandu, Nepal. The stupa and its precinct is a centre of Tibetan Lamaism in Nepal.

Seated Buddha in the ruins of the Vatadage at Polonnaruwa, Sri Lanka. 12th century A.D.

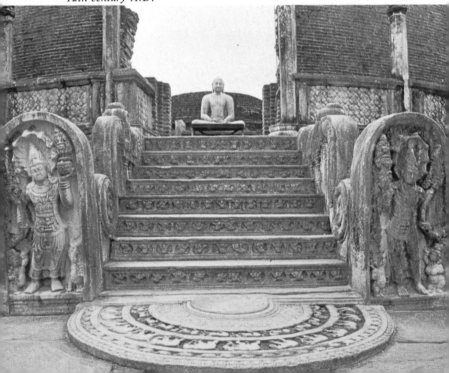

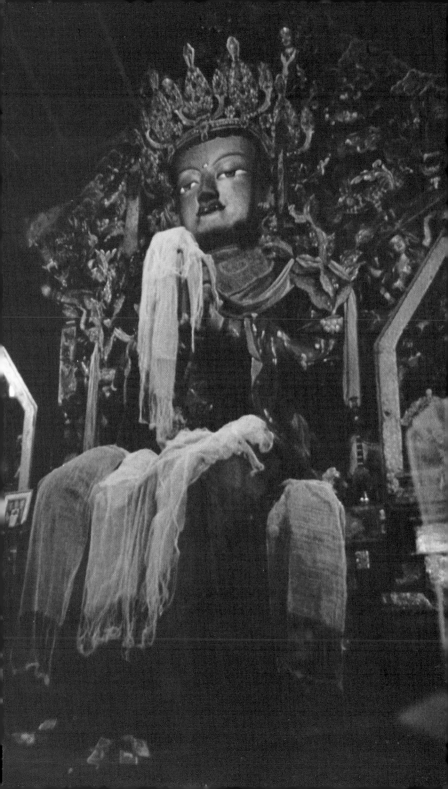

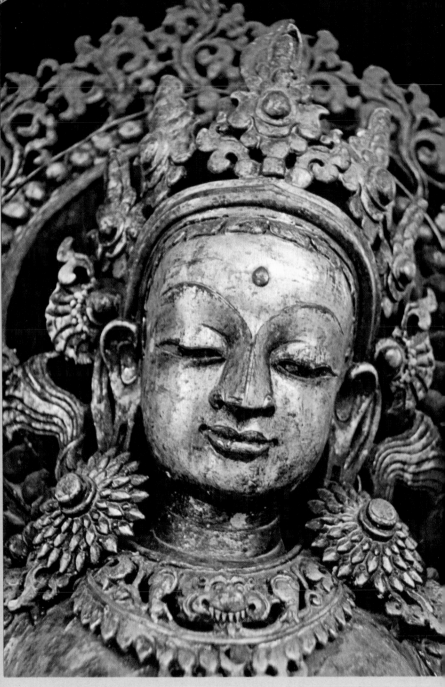

*Detail of a large gilt-bronze figure of Tara in the precinct of the Swayam-
bhunath stupa, Nepal. 18th century.*

Overleaf: *The giant image with offering scarves at the Lamaist monastery
at Ghoom, near Darjeeling, N. India.*

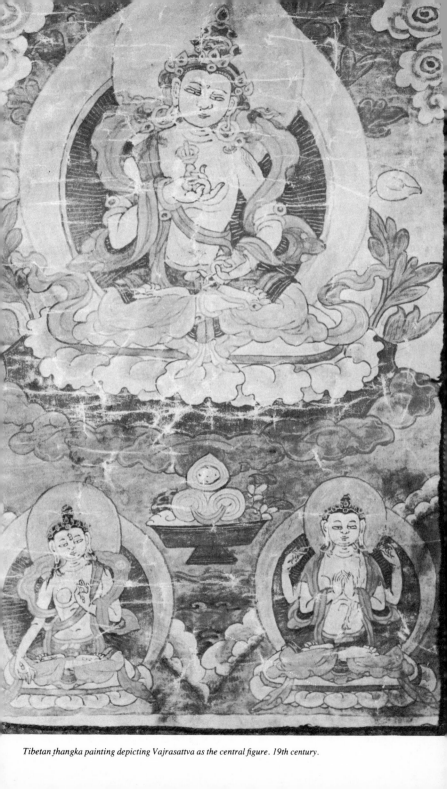

Tibetan thangka painting depicting Vajrasattva as the central figure. 19th century.

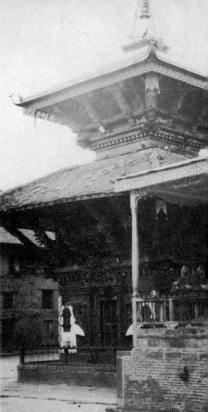

Left: *Detail of a Chinese painting of a Lohan. 16th century.*
Right: *Buddhist temple at Patan, Nepal. 17th–18th century.*

We have already seen that the teachings stress the fact of suffering and that there is no divinity, soul or spirit. The third point of impermanence is vital to Hinayana thought. Everything is regarded as an illusion. It is there but it is not there. Everything is based on constantly changing associations. Nothing that is now, was or will be. That is, what is now is not what was, and will not be. The best way to explain this is in the analogy of the flame, that the flame we see now is not the same flame that will be in a second and the second after that. The flame continues to be, but in each stage is not the same flame as the moment before, as an old man is not the child that used to be, and yet is the same being. Thus, the being of this minute is not the same being as that of the last minute, and may not be the same being in the following minute. This is the doctrine of impermanency, of sudden change. Another example is that a man may lie on a bed for four minutes and be comfortable, and for four hours and still be comfortable, but in four days, he will be in some distress, and in four

Left: *Portrait of His Holiness the Gyalwa Karmapa, now in voluntary exile at the Rhumtek monastery in Sikkim. The monastery is modelled on his original monastery in Tibet.*
Right: *Tibetan Monk of the Yellow Cap Sect blowing his long horn outside his monastery.*

years, may be in agony, and in forty years he may be dead. In four hundred years he may still be lying on the bed, but only as a collection of bones. In four thousand years, the bones and the bed will have completely disappeared. In contrast to this, if we start with a man lying on the bed and go four years before this, he was not lying on the bed, and forty years before this he might not have existed, nor the tree from which the bed was made, thus everything is in a state of flux, of being created, changing and dying.

On to this thought, one must combine the Buddhist belief in transmigration, which at first glance appears to be in conflict. How could something be transferred to another which was not part of the other, and yet which is directly affected by the actions of the being from which it is influenced?

The Hinayana is not a metaphysical doctrine, but a philosophical doctrine. It does not speculate on the origin or the end of the world,

but as it is a philosophy steeped in Indian tradition, it is not surprising that the Hinayana had a cosmology which accounted for the fact that the universe existed, but was not created by any one creator or deity. Buddha himself did not encourage speculation into metaphysics. He directed men's attention to their own world and the things that they could do to improve their own existence. It is this philosophy on self-reliance that Hinayana preaches. Refuge in this philosophy is expressed in the *Triratna*, the Three Jewels, which is repeated as a daily prayer not only in Hinayana Buddhism but also in Mahayana. It is, 'I seek refuge in the Buddha, I seek refuge in the *Dharma* (Doctrine) and I seek refuge in the *Sangha*. *Sangha* is the community of the Buddhist monks who live their lives according to the rules laid down by the Buddha. Thus, the Buddhist seeks refuge in the example given by the Buddha in his teachings and in the perfect way of life which he attained. Mahayana Buddhism is almost the complete antithesis of Hinayana, for unlike Hinayana it is devotional Buddhism. It has forsaken the lone quest for *Nirvana* and replaced it with concern for the salvation of all living creatures.

Early in the development of Buddhism, the idea evolved that the pursuit of *Nirvana* as a lone quest was self-centred and selfish and gradually the concept of the Bodhisattva emerged. It was argued that the Buddha was just one of a number of beings that had achieved *Nirvana* and that there would be a future Buddha—Maitreya. In his previous life the Buddha had reached the status of Bodhisattva—a level of spiritual being which could be enjoyed either in the human or animal form. Thus, if there were Bodhisattvas in previous ages there must be Bodhisattvas now who would later become Buddhas.

Mahayana Buddhism looks on Bodhisattvas as beings of infinite compassion—for they have reached the threshold of *Nirvana* but have turned away, preferring instead to help all living beings to obtain *Nirvana* before entering it themselves. They are in a way regarded as intermediaries. Unlike Hinayana Buddhism, Mahayana is highly philosophical and subtle and concerns itself with questions which the Hinayanaists do not face.

The concept of the Bodhisattva can be explained in the following way. Imagine a large railway station. The Bodhisattva is both the station master and the engine driver. The station is a collecting area for all the creatures on earth, each in its cycle of *Samsara* or rebirths. In the station one large train waits to leave for *Nirvana*. The Bodhisattva has the job of leading all beings to the station and on to the train. Only when every single creature has been saved will he drive the train and obtain *Nirvana* for himself and all the creatures.

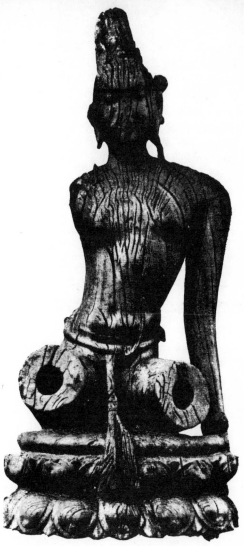

*Wooden sculpture of Avalokitesvara
found at Vikramapur, Dacca,
10th century A.D.*

To get to the station, however, they have to reach the spiritual level of Bodhisattva and it is the Bodhisattvas' job to help them to do this. Unlike Hinayana, Mahayana offers external help. The Hinayanaists simply show the way by example, a way which can only be taken alone. Mahayana, on the other hand, recognises the weakness of the individual and offers help in salvation.

The teachings of Mahayana Buddhism often seem in complete contradiction to Hinayana Buddhism. The Mahayanaists explain this in the following way. They say that the Buddha recognised that his disciples could comprehend his teachings on different levels. To some he taught the principles which became Hinayana and to others

White porcelain figure of a Lohan. Fukien, China, 17th century A.D.

who were more capable of understanding a deeper philosophy he taught the principles which became Mahayana. Thus, Mahayana and Hinayana are just two branches of the same tree of truth.

A more rational way of looking at the problem is to see the true wisdom of the man we call the Buddha. Some of the teachings and philosophies of Mahayana were far too deep to expound in their entirety. The Buddha therefore sowed the seeds of thought which would lead to the development of Mahayana thought. It is the mark of a good teacher for his pupils eventually to question his teachings and even to contradict them. Thus, the Buddha through his wise teachings knew that the path followed would inevitably lead to Mahayana philosophy.

Having said this we should remember that there is more than one school of Mahayana Buddhism and that there are a number of differences in emphasis and interpretation. Mahayana is on two levels. On its lowest level it is a devotional religion concerned with the salvation of all beings through any means available. On its higher level it is a philosophy of the highest calibre.

The Mahayanaists even question the nature of the Buddha. Hinayanaists teach that Buddha was just a man, an extraordinary man, but a man nevertheless. Mahayana Buddhism invests him with divine nature. Buddha, they say, was a physical expression of a supreme physical being which exists in three states. The Body of Essence, the Body of Bliss and the Created Body. All living creatures are part of the Body of Essence, which is eternal and universal, there-

fore, all are one and for that matter all are Buddha. The historical Buddha was the physical manifestation of The Created Body. The Body of Bliss exists in the Heavens (i.e. the railway station) where it remains and continues until all beings are united in the Body of Essence.

The Mahayana heaven, 'Pure Land' or Sukhavati is presided over by the Buddhas' Body of Bliss. Here souls of the blessed are reborn as lotus buds on the sublime lake which lies before the throne of Amitabha Buddha. Amitabha means 'Irremovable Glory'; he is also called Amitayas 'Irremovable Age'. Like the Bodhisattva, he shares an all encompassing compassion for all living things. Some sects believe that all who utter his name are guaranteed salvation and rebirth in his heaven. He, the Bodhisattva Avalokitesvara and Gautama Buddha play the major roles in the Mahayanaist pantheon.

So far did Mahayanaists thoughts go that one philosopher denied the existence of *Nirvana*. Arguing that as the cosmos was unreal, so was the act of its perception which was part of it. Therefore, *Samsara*, the process of transmigration was unreal. If that was the case there would be no need to escape it and therefore no *Nirvana*—as both *Samsara* and *Nirvana* were united in their non-entity.

Bronze Vajra or thunderbolt.

The third vehicle—Vajrayana—was a progression and a natural development of Mahayanaist philosophy. It was also the product of its time and much influenced by the prevailing Hindu thought of the 4th and 5th centuries A.D.

The Vajrayana sect developed and extended the Bodhisattva principle and combined it with elements of esoteric Brahmanism current at the time. The mysticism of the Saivite cult was adopted by Buddhists and grafted on to the Bodhisattva idea. This was the recognition of the active energy of the deity personified in the female form, his sakti. This introduced female deities into the Mahayana Buddhist

pantheon. The wholeness or oneness was symbolised by the sexual union of the deity with his consort. The theory or doctrine was explained in the *Tantras* or manuals and is thus known as Tantric Buddhism. Both Buddhas and Bodhisattvas were endowed with saktis.

The deity himself was thought of as transcendent and unapproachable, the goddess or sakti was his active force in the world and thus he was best approached through her. The idea of the unity of the complete being through the union of the male and female forces introduced sexual intercourse as a means of spiritual exercise into the ritual—it was not regarded as a vehicle for pleasure but only as a means to an end. These ideas combined with elements of magic and mysticism. The magical power is called vajra or thunderbolt.

The female aspect is prevalent at all levels from the Taras—the saktis of the Buddhas and Bodhisattvas, to the lesser divinities and demons and she-ghouls (*dakinis*). Tantric manifestations are also represented in ferocious or horrific manifestations with multiple arms and or hands. Instead of requesting the help of the deity, the believer compelled them, through ritual *mantras* and magical symbols (*yantras*), all of which were outlined in the *Tantras*.

Perhaps the most famous Tantric formula is the 'Six Syllables' *Om mani padme hum*—which translated means 'Ah the jewel is indeed in the lotus' or 'Praise to the jewel in the lotus'. Its exact meaning is ambiguous, some understand it as praising the Buddha as the jewel, others, as full of sexual symbolism, representing the divine union of Buddha or Prajnaparamita or Avalokitesvara and his Tara.

Detail from a Nepalese Tantric thangka showing Samvara in Yab-Yum. 19th century.

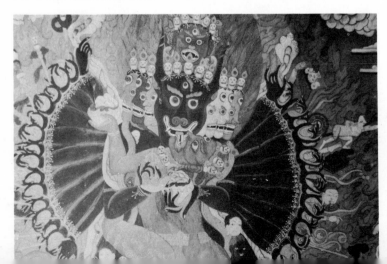

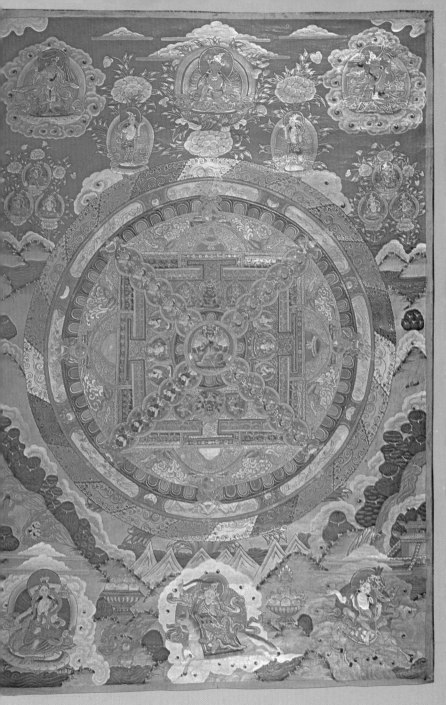

Tibetan Mandala thangka painting. 19th century.

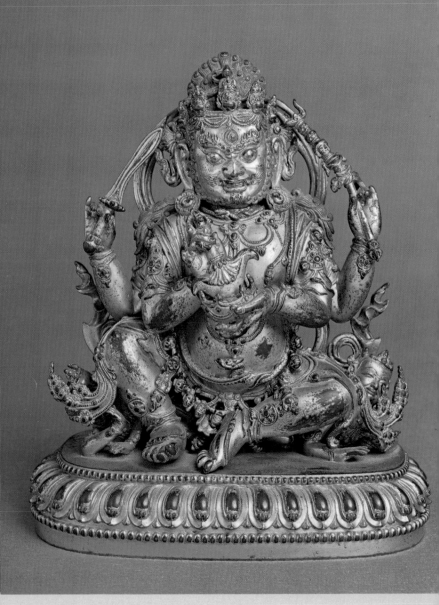

Sino-Tibetan gilt-bronze figure of Mahakala. Tantric, 15th century.

The primary purpose of the Tantricas, those who followed the *Tantras* of the Vajrayana was to obtain supernatural power. In sexual union with a female devotee he would hallucinate and visualise himself both as Buddha and as Tara.

It was the Vajrayana school of Buddhism that was introduced into Tibet in the 8th century. There it combined with indigenous beliefs in magic and necromatic ritual—Bön-po—to become what we call today Lamaism.

Through this brief survey of the Three Yanas we have seen that Buddhism is in fact many things, it could be said to be all things to all men. It is a philosophy and a devotional religion, it is a lone Path and a mass doctrine, it both denies the existence of god as well as creates its own deities. Thus, it has presented to the artist a vast array of subjects which to the uninitiated can be extremely puzzling. Before proceeding with a look at the spread of Buddhism in all its forms and its art, it will be necessary to look at another form of Buddhism which flourished in Japan and which flourishes in many parts of the world today—Zen.

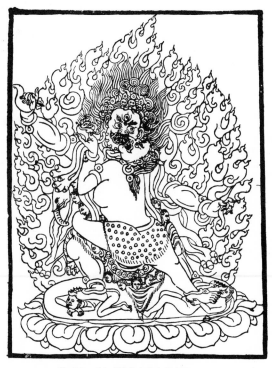

Tantric print of Mahakala in Yab-Yum.

41

3 THE WAY OF ZEN

Zen is essentially a development of Mahayana Buddhism, but it is a development which on the face of it appears to have no connection with it at all.

Zen rejects the Hinayana concept of the quest for *Nirvana*, the extinguishing of a flame by gradually gaining merit over countless lives. It also rejects the Mahayanaist belief in salvation through the use of magical symbols, formulae and rituals. It believes instead that 'Enlightenment' or what the Japanese call *Satori* is instant, and can be achieved by anyone at any time. This Enlightenment can come just as a bolt of lightning, out of the blue, completely unexpected. It cannot be desired nor grasped, for the very act of desiring it will deny it. In the same way it cannot be achieved by not desiring it, for the act of not desiring it is conscious and is therefore a desire not to desire. Zen is a way of life and a life of a way. Zen is, it cannot be described. It cannot be understood, for to understand it would not be Zen.

The principles of Zen were present even in the earliest forms of Buddhism, but were not developed. Later they were extracted and stripped of their trappings to become a Path. Zen is in many ways the very essence of Buddhism.

Zen as we have seen cannot be described by words, for any description of Zen would not be Zen. Having said this it is possible to lead towards Zen, to guide along the Path, but any description of the meaning and practice of Zen would not be accurate, for Zen cannot be achieved by words or language, for it transcends the shackles of conscious thought. If it cannot be described by words, how then can it be transmitted? Well the true Zen answer is that it cannot be transmitted. What then is the purpose? Again, the answer would be that there is no purpose. The inference would then be that it is illogical. Zen is illogical but it is also logically illogical.

Because Zen cannot be imprisoned by words, it has resorted to various means to convey or implant the seed that is Zen. These include, amongst others, painting and calligraphy. It also includes the use of stories or questions and answers, *Wen-ta* (Chinese) and *Modo* (Japanese) and *Koans*, which is illogical in itself for as we have seen, words are not Zen and yet, is Zen words?

Alan Watts in his dedication to his book *The Way of Zen* puts it in perspective by saying 'To Tia, Mark and Richard, who will understand it all the better for not being able to read it'. Zen then is a freedom, a freedom from logical thought; logical thought brought about by the restriction of language. It is often assumed that all constructive thought must use language, but what language does a

young child use? His mind is not yet shackled by convention, it has the freedom to see things as they really are. It is a natural mind. Zen is an innocence, Zen is seeing and yet not seeing. The famous Zen teacher and writer of modern times Dr. D. T. Suzuki uses the following famous Zen verse to great effect.

Empty-handed I go, and behold the spade is in my hands,
I walk on foot, and yet on the back of an ox I am riding,
When I pass over the bridge,
Lo, the water floweth not, but the bridge doth flow.

Therein lies Zen. It is the bridge and at the same time it is the chasm itself. Another Zen story asserts that when one first sees a mountain, it is a mountain, then it is not, but finally it reverts to being a mountain.

But what has all this to do with Buddhism? Everything, for in reality it is the only way that Buddhism could truly develop in the Far East. It is the Chinese interpretation of the mystical and philosophical aspects of Mahayana, rejecting not only scriptural authority, and iconolatry but also all forms of external control. The influence of the Tao can also be seen, in fact, in later forms of Zen, the Dharma and the Tao were almost considered synonymous. Lao-tzu, the author of the famous Tao classic—*Tao-te-che*—in fact wrote:

THOSE WHO KNOW
do not speak

THOSE WHO SPEAK
do
not
know ,

echoing the Zen assertion that truth cannot be expressed by words. The Zen we see today is the product of Japanese social development on Chinese intuitive philosophy.

The story of Zen Buddhism in fact begins not in China or Japan, but in India. The seeds of Zen had germinated from the teachings of the Buddha early in the history of Buddhism. It is said that Zen was transmitted by the Buddha without words. He was sitting with his disciples when a prince came to him and offered a golden flower, requesting him to tell him of the *Dharma*. After accepting the flower, the Buddha sat and, holding it high, looked at it in complete silence. Observing this, one of his companions, the venerable Mahakasyapa, smiled. Zen was born! This smile is said to have been passed down through twenty-eight patriarchs, the last of whom was the founder and first patriarch of Ch'an Buddhism (Zen) in China, the Indian philosopher Bodhidharma, who entered China in A.D. 520.

Some of the greatest thinkers in India were Bodhidharma's predecessors. They include Ashvaghosha and Nagarjuna. The latter is the author of the famous Sutra, Prajna-paranamita, the so-called doctrine of complete nihilism, or non-existence, which had a profound effect on the early development of Zen.

When Bodhidharma arrived in China, he was summoned by the Emperor, who believed himself to be a good Buddhist. He told Bodhidharma that he had built many temples and monasteries, ordered copies of scriptures to be made and had supported the *Sangha*. He then asked the sage what merit he would gain from this. 'None at all,' was the reply. This naturally shook the Emperor, so he asked Bodhidharma what was the first principle of Buddhism. 'Vast emptiness,' was the reply. By now the Emperor must have thought that it was a madman who stood before him, because he was, according to tradition, contradicting what the Chinese had accepted as Buddhism. Finally, the Emperor asked, who then was he, who said these things? (i.e. Bodhidharma). 'I have not the faintest idea,' answered the sage. Thus, according to tradition, was the first teaching of Zen (Ch'an) in China, which became synonymous with Chinese Buddhism.

45

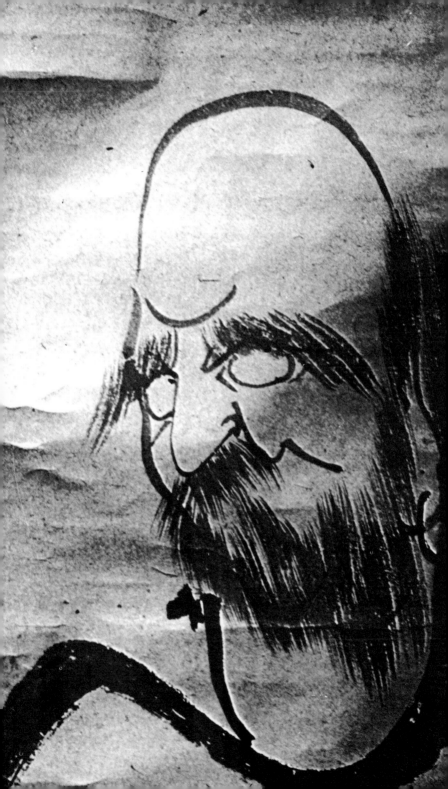

Another example of Bodhidharma's vision is given in a story concerning one of his students. The student, after waiting in the snow for a week before being given an audience, asked the sage to pacify his mind.

'Show me this mind,' said the teacher.

'I cannot produce it,' said the student.

'Then I have already pacified it,' said Bodhidharma, and another seed was sown. Bodhidharma's teachings are contained in the following verse:

A special transmission outside the Scriptures;
No dependence upon words or letters;
Direct pointing to the soul of man;
Seeing into one's own nature.

After a number of years of fruitful growth, the practice of Ch'an continued in China until the 12th century, when the impetus passed to Japan, where it became the major force of Buddhism, the religion of the Samurai. The last Chinese Patriarch was the 6th, Hui-neng (A.D. 638-713) (Wei Lang—southern dialect). He was also perhaps its greatest exponent. In Japan, he is known as Eno.

Hui-neng's succession as the 6th Patriarch marked a split in Chinese Ch'an Buddhism, for being a very lowly and humble monk on his succession, there was much jealousy of him, especially by the instructor of monks, Shen-hsiu. Knowing of this the 5th Patriarch, Hung-jan, advised Hui-neng to leave the monastery and go south, this he did and established a southern school of Ch'an in Canton. Shen-shiu, not to be out-done, claimed the right to the 6th Patriarchy, and continued as head of his monastery, obtaining Imperial Patronage. Later, after an enquiry by the Imperial Commission, Hui-neng was recognised as the true successor and 6th Patriarch, and Shen-hsiu was given the title of 7th Patriarch, which was something of a compromise and was never fully recognised. As Hui-neng appointed no successor, the Patriarchy died with him. His disciples continued to teach, and over the years established five schools which flourished during the 8th-13th centuries, the T'ang and Sung dynasties. These five schools are Lin chi (Japan—Rinzai), Tsao tung (Soto), Yun men (Ummon), Kuei yang (Ik-yo) and Fa yen (Hogen). In Japan, the Rinzai and Soto schools became the most important. Soto was established in Japan in 1227. Rinzai is the 'violent' school of sudden Enlightenment, while Soto is more meditative. Rinzai was founded by Lin chi (died A.D. 867), who was noted for his violent outbursts, not emotional but calculated psychological aids. Lin chi

perhaps gives us a perfect example of what Zen is. He emphasised that Buddhism was not to be looked on as a system of self-improvement, or a way of obtaining Buddhahood. He said:

'If a man seeks the Buddha, the man loses the Buddha!'

Zen put down its roots in Japan as early as the 7th century, however, it did not properly flourish until the 12th century. In 1191, Eisai (1141–1215) a Tendai monk who had studied in China, returned to Japan to establish a monastery of Lin chi (Rinzai) Buddhism at Kyoto. Kyoto was also the headquarters of Tendai and Shingon Buddhism, however, it was under the patronage of the Hojo family that Zen firmly established itself at Kamakura. Soto was established a few years later by Eisai's pupil, Dogen. The main difference between the two schools is in the importance given to the *Koan*. In Rinzai, the *Koan* is the basis for spiritual Enlightenment, while in Soto it is much less so.

Unlike other schools of Buddhism, Zen does not use a temple as such, but instead uses the Meditation Hall. This was an idea introduced after the death of Hui-neng by the Zen Master Hyakujyo Nehan (720–814), also known as Pai-chang Nich-p'an. He founded the first Zen monastery, and devised a strict set of rules. He originated the saying 'No work, no food'. The Meditation Hall does not need a central image.

The *Koan* is an external invention, and is a means of passing on the experience of Zen with the very minimum of falsification, usually non-verbally. This may seem a contradiction but in fact is not, the words used in the *Koan* are but a trigger to insight and *Satori*. The *Koan* is in fact a problem based on the *Mondo* (Wen-ta) anecdotes of the great Zen masters. The aim is to make the student experience Zen truth, the physical experience of the verbal words—it is a demonstration of the student's intuitive reaction.

Another apparent contradiction in Zen is the use of *zazen* or sitting meditation, which is known to both Rinzai and Soto Zen. *Zazen* is practised for many hours each day, during which time the student aims to have right posture, and breathing. It is not meditation in the Mahayana sense. It is sitting for the sake of sitting, becoming calm, and discovering one's true nature. It is becoming one. Objectivity is lost.

Above all, Zen is uncontrolled, it is as free and easy as its art. Its spontaneity has triggered some of the greatest works of art, not only of Buddhism, but of the world. It has inspired painting and calligraphy, as well as poetry. Without doubt, however, Zen's greatest art is the art of life.

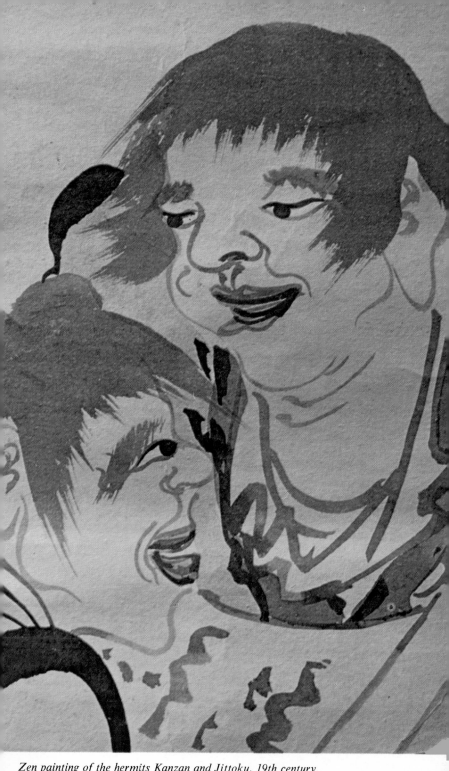

Zen painting of the hermits Kanzan and Jittoku. 19th century.

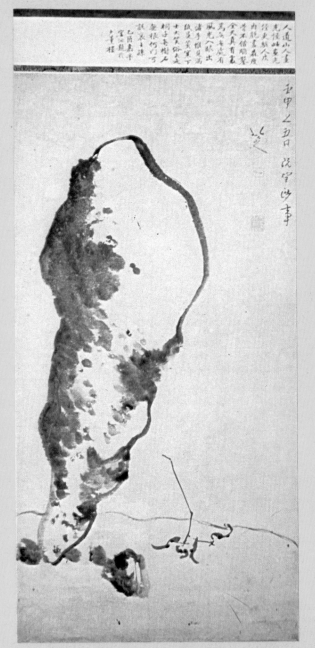

Chinese hanging scroll painting in the Ch'an tradition of seeds beneath a rock. Chu Ta (1625–1700).

Right: *Sino-Tibetan gilt-copper figure of Amitayus – Lord of Infinite Life. 18th century. The hands originally held a vase of amrita (ambrosia) surmounted by a flower.*

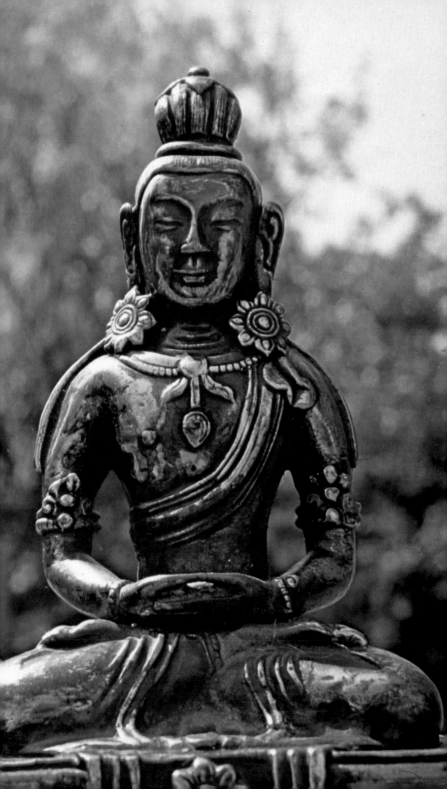

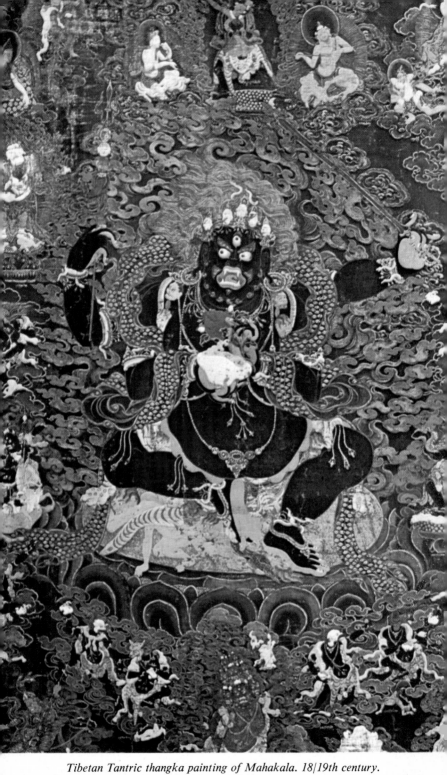

Tibetan Tantric thangka painting of Mahakala. 18/19th century.

4 THE SPREAD AND DEVELOPMENT OF BUDDHIST ART

In early Buddhist art, the figure of the Buddha in his historical life was never depicted, i.e. as Sakyamuni Buddha, unlike his previous lives as related in the *Jatakas*, where, when incarnate as a human form, he was shown as such.

The first figures of the Buddha himself were sculptured by the Gandharan school of north-west India, as early as the 2nd century A.D. However, the first dateable representation of the Buddha is the figure on a casket found at Bamiyan in Afghanistan, which may date to the first century B.C. The earliest dated figure in China is dated A.D. 338.

Gandhara was converted to Buddhism by the Emperor Asoka in the 3rd century B.C. The sculpture of Gandhara express indigenous Buddhist ideas, but in a pseudo-Hellenistic style. This influence from the Mediterranean took many years to reach Gandhara by way of Iran, but was reinforced by Roman influence from the eastern centres of the Roman Empire, as a result of trade established between Rome, Western Asia, and India in the first century A.D.

Other schools of sculpture developed, producing great master-pieces at Sanchi, Bharhut, and Bodh Gaya. In the South, the southern thrust of Buddhism, Hinayana, provided the inspiration for the fine sculptural style of the Andhras. Some of the finest examples of which have been found at Jaggayyapeta and Amaravati.

Buddhism in Sri Lanka (Ceylon) is said to have been introduced

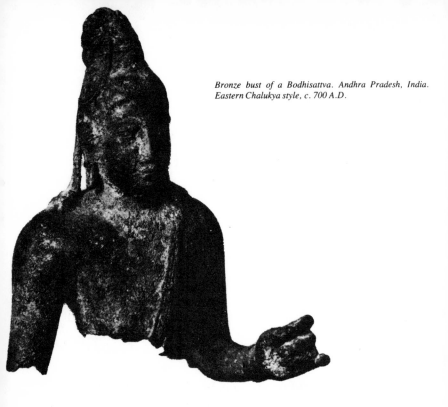

Bronze bust of a Bodhisattva. Andhra Pradesh, India. Eastern Chalukya style, c. 700 A.D.

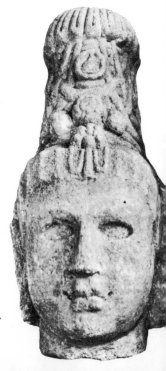

Stone head of a Bodhisattva. Anuradhapura, Sri Lanka, 7th century A.D.

by Mahinda the son of the Indian Emperor Asoka. The Sinhalese King, Devanampiya Tissa (247–207 B.C.), who was much impressed by Asoka's propagation of Buddhism met Mahinda at Mihintale about eight miles from the ancient capital of Anuradhapura. Once converted, Tissa built the first Buddhist monuments on the island. He built the famous Maha Vihara at Anuradhapura, and a Vihara at Mihintale; he also dedicated the royal pleasure gardens, which were situated in the south of Anuradhapura to the *Sangha* or priesthood.

Although much of the early documented accounts may be somewhat legendary, there can be little doubt that Hinayana Buddhism, or what we call Theravada Buddhism was the principal faith on the island from the 2nd century.

Sinhalese monuments have a number of common features with the Buddhist monuments of Indo-China. The first Buddha images date from the 2nd to 3rd centuries, and are clearly inspired from the late Andhra art of Amaravati in South India. This kind of figure can be found at a number of places in South East Asia. This is due in the main to the Indian traders from the Andhra Empire. In Sri Lanka from the 7th century onwards elements of the Indian Gupta style can be detected in the art of Polonaruwa, mainly through the influence of Indian Pallava sculptural art.

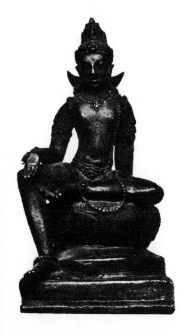

Bronze figure of Manjusri. Java, 10th century, A.D.

55

Buddhism found its way to Indonesia between the 2nd and 6th centuries A.D. It was the religion of the Indian merchants and found a home in their settlements. These merchants traded with Burma, Indo-China, Indonesia and even China. The first Buddhist art was imported from India, but later it was copied, and developed into a fully indigenous tradition. Thus, the seed of inspiration and art was Indian, but the growth was Indonesian. The early doctrine was Hinayana, but later from the beginning of the 7th century, Mahayana was introduced. Vajrayana even found a niche. Indian influence continued with links with the Andhra, Gupta and Pala Empires.

The religious and cultural history of Indo-China is complex, with a web of influence woven by both Chinese and Indian ideas on to a support of Indonesian social structure. Influence from India came from both north-east and south-east, together with modified influence from Burma, to this can be added Indian ideas from north and north-west India which reached Indo-China by a curved arc. Early Indian Andhra influence is from Amaravati. Thus, Indian influence was in two parts, with Chinese influence coming from Annam. A fairly sharp dividing line, however, can be drawn between the two. The development of Buddhist art in Indo-China is quite unique, with some of the finest examples of Buddhist art coming from that area.

The iconometric form of Buddha which developed in Gandhara spread to other parts of the Buddhist world, where it formed the foundation of all future representations of the Master. In China, the form can be seen in the Udyana style. It was the practice to import images from India whenever possible. There are a number of stories that bear this out, including the tale of Fa-hsien the famous traveller in India between the years A.D. 399–414. The significance of this importation on Chinese sculpture is tremendous, for it means that periodically Indian images would have reached China, making it possible for Indian artistic trends to directly influence Chinese sculpture. Thus the superb religious sculptural styles of the Gupta (4th–6th centuries A.D.) and other periods of India, had a direct bearing on Chinese sculpture. To this we must add the influence from Central Asia (which in its way too was influenced from India). We shall see that Chinese Buddhist sculpture is a unique blend of Indian, Central Asian and indigenous Chinese artistic ideals.

The early Chinese images followed the Gandharan style closely, but as time passed the figure was modified to suit Chinese taste. Although the Gandharan sculptors were the first to produce an anthropomorphic image of the Buddha, it was the Gupta artists

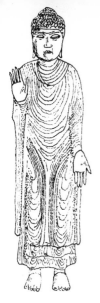

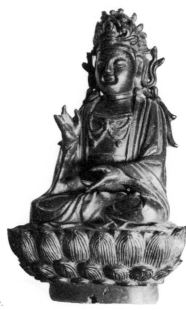

Udyana figure of the Buddha in the Sieryo Temple, Kyoto, Japan.

Chinese bronze figure of Avalokitesvara. 16th century.

who inspired the figures with the mystic and dynamic spirit of the Enlightened One. The Indian Gupta style affected the development of T'ang art in China, but the Chinese indigenous style is the dominant factor.

T'ang figures are less rigid than those of the preceding period, and although they conform to iconographic canons there appears to be more individuality which reflects the sculptor's ability to work within strict iconographic dictates. More attention is paid to the form of the body rather than the contrived decorative designs of the drapery. The effect is more sensuous. The lofty aspirations of the T'ang sculptors produced works of art which enable the onlooker to have an aesthetic experience as a way of achieving spiritual harmony. Spiritual beauty in fact was expressed in physical terms.

In Korea, sculpture was strongly influenced by Chinese artistic traditions. The ruins of the Pulguk-sa Monastery and the cave temple of Sokkul nearby, once housed some of the finest specimens of Korean Buddhist art. The sensuous treatment of the sculptured figures shows strong influence from T'ang China.

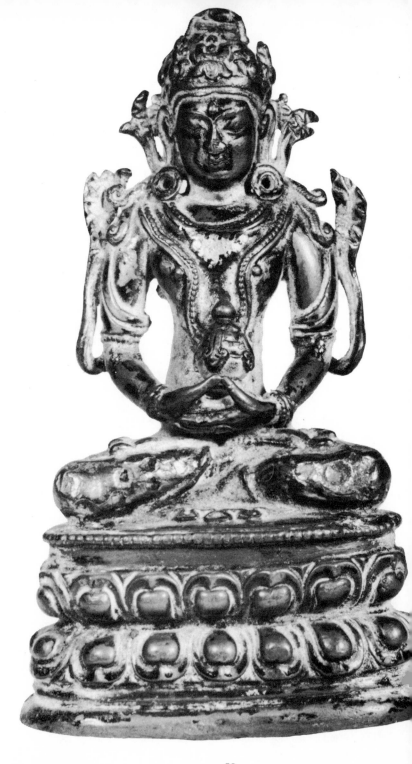

The arrival of Buddhism in Japan in the 6th century, brought with it a demand for metal images. The first images appear to have been brought from Korea to Japan by the Buddhist mission in A.D. 552. Other records relate that an artist versed in the making of images arrived in Japan from Korea in A.D. 557. It will be evident from this that the first images in Japan reflect the Chinese artistic trends and were either made by foreign artists or Japanese artists influenced by contact with Korea.

By A.D. 604, Buddhism had become firmly established and was made the State religion. It was during this period that the famous Horyu-ji temple was built at Nara. Bronzes made during the Nara period (A.D. 710-94) merely followed the T'ang style and because of this we often look to Japan to furnish us with illustrations of types which have disappeared in China.

The caves at Tun-huang, situated on the border of China with Central Asia, house many Buddhist art treasures. A fine set of paintings, dating to the early 6th century A.D., are preserved in the twenty-two caves of the Wei dynasty. These paintings illustrate the continuation of the early traditions of figurative and landscape painting.

During the T'ang dynasty, we see influences from India and Iran mixed with Chinese tradition to form an integrated and harmonious pictorial art form. The motifs were influenced by the Tibetan and Indian ideals of Mahayana Buddhism. Apart from the fragmentary paintings of this period preserved at Tun-huang, we have few other examples, as the paintings in the temples of the provincial centres have not survived.

In eastern India, the Pala and Sena dynasties (A.D. 730-1197) succeeded to the empire of Harsha in the Gangetic Valley. The Palas, who were great patrons of the arts, were adherents of Tantric Buddhism, which differed from Mahayana Buddhism, and which included many traits of Hinduism. It was the basis of the Buddhism that was imported into Tibet by Padmasambhava, but under the Palas it gradually assimilated aspects of Saivism and Vaisnavism (the worship of Siva and Vishnu respectively) until it finally disappeared in the 12th century. The last great centre of Buddhism was at Nalanda in Bihar, not only a university city but also a great artistic centre.

In India Buddhism was shattered by the impact of the Muslim invasion at the close of the 12th century. Thousands of Buddhist monks were slaughtered, the few that escaped were scattered throughout India. The invasion not only destroyed Buddhism, but also to a certain extent art, both Hindu and Buddhist, over a large area of

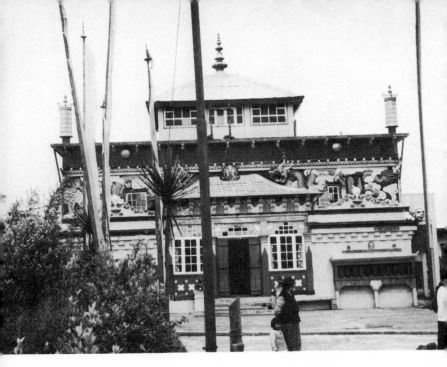

The exterior of the Tibetan monastery at Ghoom near Darjeeling, N. India.

northern India.

In Tibet during the 11th century, a fully developed form of Vajrayana, 'The Vehicle of the Thunderbolt', a Tantric school of Buddhism was introduced by Atisa and missionaries from the Vajrayana monastery of Vikramasila in Bihar. Atisa, an Indian monk, founded the Ka-dam-pa Sect in 1040. This was later reformed by the teacher Tsong-ka-pa to become the premier sect of Tibet, the Yellow Cap Sect or Ge-lug-pa. Another sect formed in the 11th century was Kar-gyu-pa founded by Mar-pa, a disciple of Atisa.

In Japan, a number of new sects came into being during the Early Heian period (A.D. 794–897) which had a profound effect on the art of the time. The Tendai school was introduced by Dengyo Daishi in A.D. 805, while Shingon was founded by Kobo Daishi in A.D. 806–807. Thus, the simplicity of the early Buddhist art of the Nara period was superseded by an art strongly influenced by more elaborate iconographies of Tantric Buddhism. Shingon was based on Indian Tantric Buddhism with its mystic and esoteric rituals. Its origins can be traced back to the Vajrayana sect.

The fearsome and awful aspects of Buddhism were emphasised in paintings and sculpture. A popular form of painting used to express the complexities of existence as seen by the Tendai and Shingon

faiths was the *mandara* (Sanskrit: *mandala*) a kind of magic circle diagram illustrating various beliefs of present and future lives. *Mandaras*, however, are more of interest for their fine execution and draughtsmanship than for their artistic merit. The art of Shingon Buddhism was severely restricted by iconographic canons, however, Japanese artists overcame these difficulties far better than those of the countries who embraced Tantric beliefs.

By the Heian period proper (A.D. 897–1185), also known as the Fujiwara period, the esoteric forms of Buddhism had lost their hold. The sect of Jodo, devoted to the worship of Amida Buddha, Lord of Boundless Light, became popular. Paintings became quieter and more realistic. Amida and the Bodhisattvas were popular subjects both in the round and in two dimensions.

In China, esoteric Buddhism also had an effect on the art. The influence of Tibetan Lamaism and Tantric doctrines can be seen clearly in the many-armed and headed figures of the Ming dynasty (1368–1643) many of which are in museums and private collections. A number of Lamaist monasteries were established in China, and many of the bronzes made for this sect are difficult to distinguish from the Tibetan. Some images in fact bear Tibetan inscriptions. Subjects vary, and include many of the deities from the Tibetan pantheon.

Perhaps the sect that had the most lasting and profound effect on both the art of China and Japan was Ch'an, the Japanese Zen. Ch'an painting, expressed as landscapes, became popular in Sung China (A.D. 960–1280). They displayed an enigmatic view of life through misty scenes of mountains and lakes or similar subjects, echoing through a vision almost of emptiness, the majestic power of nature. Landscapes were supreme during the Sung dynasty and some of the greatest of Chinese painters were to find expression in that field of art. This popularity of landscape painting was the result of a national change in philosophy and outlook. Whereas T'ang China devoted itself to the enjoyment of the pleasures of the world, the philosophy of Sung China was introvert, searching for the spiritual self.

In Japan, Zen grew in popularity, until in the 14th century it became a major stimulus to painting. Artists inspired by the teachings, tried to convey the message of Zen, through their paintings, strongly influenced by Chinese Ch'an paintings and techniques. Many artists of the period were in fact members of the Zen priesthood. Most of the Ch'an pictures are in Japan, where they were more appreciated and where the philosophy of Zen Buddhism is still practised.

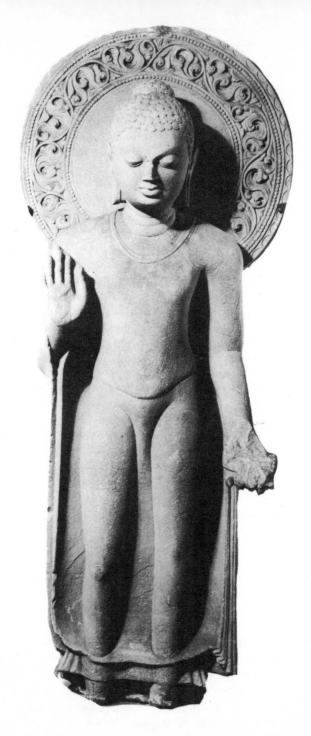

Magnificent standing figure of the Buddha from Sarnath. Gupta period. 5th century A.D.

5 INDIA

No truly Buddhist monuments exist for the time spanning the death of the Buddha to the Emperor Asoka. There are a number of reasons for this. During the early years, the *Sangha* did not need large permanent temples or monasteries, and if they existed at all, they would probably have been simple wooden structures, evidence of which has not survived. The *Sangha* were mobile, roving around the country, only resorting to shelter during the rainy season. Images of the Buddha, too, were absent, they were only introduced much later. The funerary mound or stupa was the only form of monument that can be connected with Buddhism, although this was a survival of earlier traditions. Although originally only a simple earthen mound, nevertheless it is the only Buddhist monument that can with certainty trace its origin back to the early days.

The Emperor Asoka is almost legendary in the history of Buddhism. He is, however, a very real historical figure, and has left his mark not only on India, but also through his campaigns, both military and religious, on the history of the world. During the war with the Kalingas in Orissa, he was so concerned by the bloodshed, terror and distress caused by his campaign, that he was converted to Buddhism, a philosophy, as we have seen, of compassion. A strange 'about-turn' for a military leader of his stature. The event is recorded on one of the edicts which he erected. Other inscriptions suggest, however, that his conversion took place in three stages. The

campaign against the Kalingas was only the final act. The Emperor, once converted, used all his energy for his new religion. His campaigns were campaigns of conversion, and he used the wheel of the *Dharma* on his official monuments and pillars. The most famous of his pillars is the capital found at Sarnath, now used as the emblem of the Republic of India. This famous sculpture consists of the foreparts of a maned lion, facing the four corners of the world, mounted on a stone drum, which is supported on an inverted lotus. The drum is decorated in relief with animals and supported by the *Cakra* or wheel.

In his zeal, Asoka is said to have founded 84,000 stupas and sent missionaries to Nepal, Sri Lanka, Burma, Kashmir and even to the Mediterranean. The stupa was originally used as a funerary monument, but in Buddhism it came to be used as a reliquary, first, of the physical remains of the Buddha, then of objects connected with him, and when all these were exhausted, images of the Enlightened One.

They also served to mark places sacred to the memory of the Buddha, such as the Lumbini Grove at Kapilavastu where he was born; Bodh Gaya near Patna, where he obtained Enlightenment; Sarnath near Varanasi where he preached his first sermon in the Deer Park; Kushinara, where he died. Basically the stupa is a hemispherical mound or structure, which is surmounted by a stone umbrella and which is, though not always, surrounded by a balustrade. Over the years, there have been numerous variations, coloured by time and geography. Asoka is said to have constructed the original stupa which forms the nucleus of Stupa I at Sanchi. The monument we see today is an enlarged version with the famous sculptural gates which were constructed between the first and second centuries A.D.

In early Buddhist art, as on the Bharhut Stupa in central India, which dates to the 1st century B.C., inscriptions confirm the presence of the Buddha Sakyamuni, indicated by symbols such as the Bodhi Tree, footprints, wheel, parasol and stupa. Fine Buddhist sculptures of the early period are also found at Sanchi and Bodh Gaya. Although it was the practice not to depict the incarnate Buddha, Sakyamuni, in these early reliefs, representations of him in his previous lives as recorded in the *Jatakas* were executed, showing him either in animal or human form, depending on the incarnation.

The art of Bharhut is thought to have developed from the artistic trend started at Sanchi. The sculptures are carved in very low relief giving the impression of a drawing without dimensional approach. The human figures are primitive in execution and contrast strongly

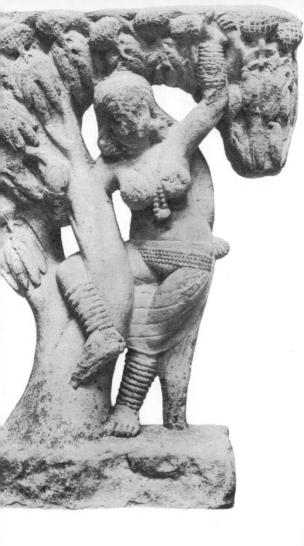

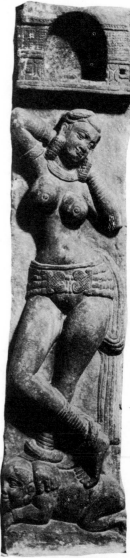

Above: Stone sculpture of a Yakshi from Sanchi, Central India. 1st century A.D.
Right: Sculpture of a Yakshi from Mathura. 2nd century A.D.

with the soft flowing curvilinear forms of the botanical compositions which dominate the style. The figures at Bharhut are in deeper relief than at Sanchi. The large single figures seem to be almost divorced from the main composition of the sculpture. Little attention is paid to anatomical accuracy.

The sculpture at Bodh Gaya in Bihar, carved about the first half of the 1st century B.C. is in the Bharhut style, but is more aesthetic and generally more advanced than that at Bharhut. It has a greater sense of rhythm and movement, created by softer and subtler contours.

Of the early Buddhist art in India, there is little doubt that the finest is to be found at the Great Stupa at Sanchi. Similar in style to that at Bharhut, it is nevertheless an advance on the Bharhut style. Unlike Bharhut, the railings are left plain, the sculptures only appear on the gateways, portraying scenes from contemporary life, from the simple ways of the country to the rich aristocratic splendour of the court. Already at this early date, the basis of the classical school had been established. The figures are extremely natural, and have a great sense of movement.

South India also began to produce Buddhist sculpture during this period. Some of the earliest examples come from Jaggayyapeta, about thirty miles north-west of Amaravati. Like the reliefs on Stupa II at Sanchi, they are extremely shallow, but already the Southern preference for the elongation of limbs and for slim modelling is evident.

Gold Buddhist reliquary in the Ghandhara style. 2nd–3rd century A.D.

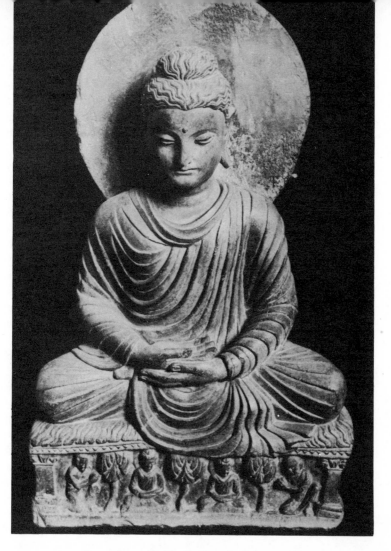

Stone sculpture of Buddha. Gandhara, 1st–2nd century A.D.

The first sculptures of Sakyamuni were created as early as the 2nd century A.D. in Gandhara in north-west India. Gandhara was the name given to the area on the North-West Frontier around Peshawar. The principal centres were Purushapura (Peshawar) and Pushkalabati (Charsadda), the districts of Hazara, Rawalpindi, and Taxila (ancient Takshasila) were sometimes included in the province.

The style which developed there later became stereotyped and spread to Baluchistan, Afghanistan, Central Asia, and even to

China. The style is pseudo-Hellenistic, reinforced by Roman Hellenistic ideas, as a result of Indian trade with Rome and Western Asia in the 1st century A.D. This, therefore, is more correctly termed a Romano-Buddhist school, as many of the Hellenistic ideals had been Romanised before they influenced Indian sculpture.

Gandhara figures of the Buddha wear toga-like robes reaching down below the knees. The folds of the robes are well defined and the limbs thick and even plump. The head is reminiscent of the Greek rendering of the head of Apollo. Features are full, the eyes half open, indicating divine peace. The nose is almost Roman, its lines continuing upwards to form stylised brows. The *urna* or 'third eye' is on the forehead, the ears are pendulous and the robes strongly carved and well proportioned. The hair is long and wavy, and the craneal protuberance, *usnisa*, disguised by an adaptation of the topknot, similar to the krobylos of the Greek sun god. The proportion of the figure is that of five heads, as are the figures of late Roman sculpture. The sculpture of Gandhara is almost entirely Buddhist. Stupas and other monuments were covered with sculpted figures and reliefs. Among the subjects were scenes illustrating the life of the historical Buddha, the most popular being the Conception, the Miraculous Birth, the Great Departure and the Great Enlightenment. Unlike those of Bharhut and Sanchi, the Gandharan sculptors made a real attempt at perspective.

During the reign of the Kushan emperor, Kanishka in the 2nd century A.D., Buddhism reached its zenith. In India, Mahayana ideals had already made themselves felt, for in addition to figures of the Buddha, there are representations of Bodhisattvas. These appear to be purely indigenous sculptural innovations, the loin cloth, turban, hair style and profuse ornaments being characteristic of the period. The seated figure of the Buddha in a leg-locked yoga position was also an original Indian idea. As in later schools, much of the sculpture was meant to be covered in plaster, painted and then gilded, though few examples with any trace of colour survive.

The importance of Mathura in the development of Buddhist art begins in the 1st century A.D. An ancient and prosperous city, situated to the south of present-day Delhi, near Agra, it was in ancient times a converging point of trade routes. It was at Mathura that the idea of iconographic images of deities began to shape a new conception of Indian art.

At Mathura, reliefs gave way to the principal expression of the human figure. New ideas of composition were developed around the figure, regulated by iconographic dictates, which specified formulae

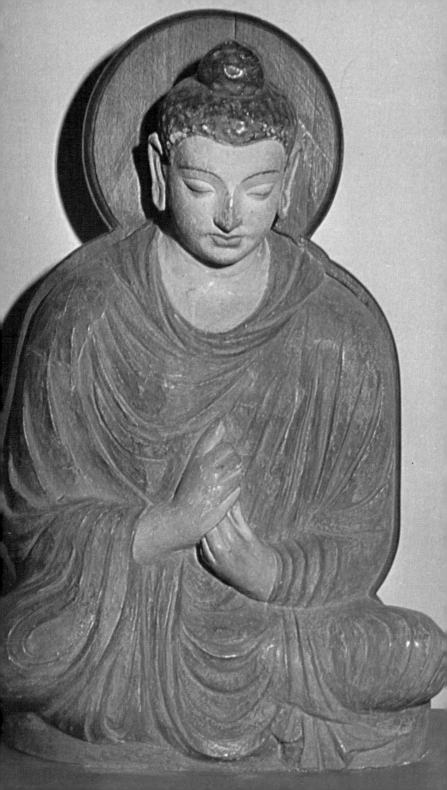

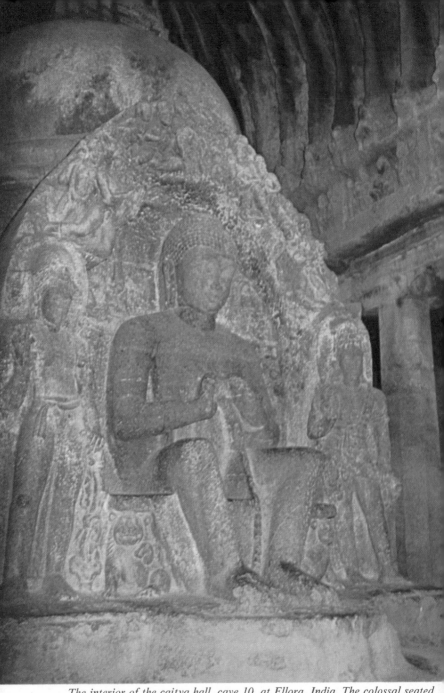

The interior of the caitya hall, cave 10, at Ellora, India. The colossal seated figure of the Buddha is flanked by his attendants Padmapani and Maitreya. c. 700–750 A.D.

Right: *Gupta sculpture of the Buddha from Sarnath. The Gupta representation of the Buddha became the archetype for Buddha images throughout the Buddhist world. 5th century A.D.*

Overleaf: *Gandhara sculpture of Buddha, painted in polychrome colours.*

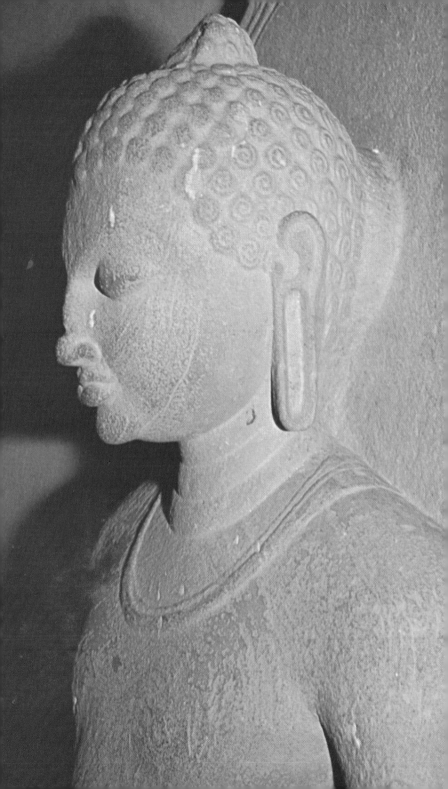

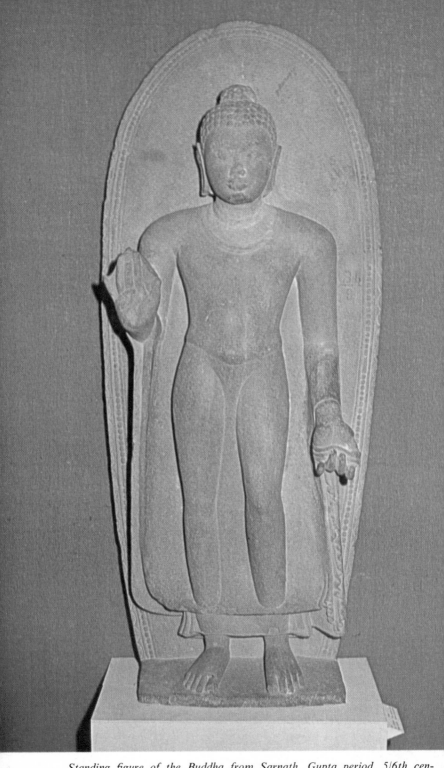

Standing figure of the Buddha from Sarnath. Gupta period. 5/6th century A.D.

for both primary and secondary figures. The well-known image stele was born.

The sculptors of Mathura created both Buddhist, Brahmanical (Hindu) and Jain figures with equal ease. New ideas were introduced; the *urna* became a simple raised dot, the *usnisa* a spiral, but in spite of greater anatomical contours and detail, dynamic force and mystic spirit seems totally absent. Gandharan influence can be seen in the treatment of drapery, but Mathuran sculpture is completely indigenous in expression. Nude and semi-nude female figures (*yakshinis* and *apsaras*) were carved on rail-pillars; though related to the yakshinis

Stone sculpture of Buddha, Mathura. 2nd century A.D.

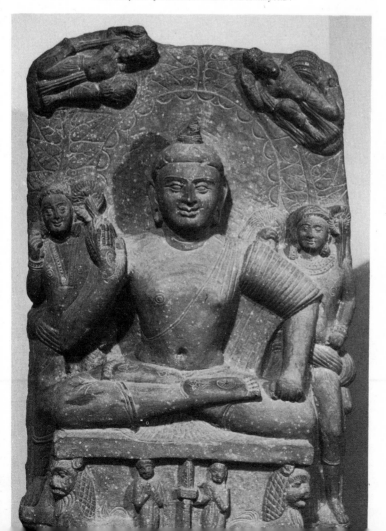

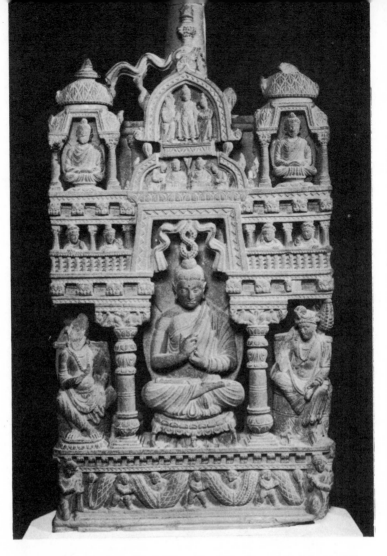

Gandharan stone sculpture of the Buddha and the miracle of Sravasti. 1st–2nd century A.D.

at Bharut, Sanchi and Bodh Gaya, they are sculpturally far in advance. They are beautifully carved, their sculptural plasticity creating strong erotic and sensual overtones. The other great artistic school of the period responsible for superb works of Buddhist art, developed at Amaravati in the Deccan, and was to last for several hundred years, until the decline of the Andharan dynasty. Amaravati, once the finest monument of the Buddhist world, today lies as a sprawling ruin.

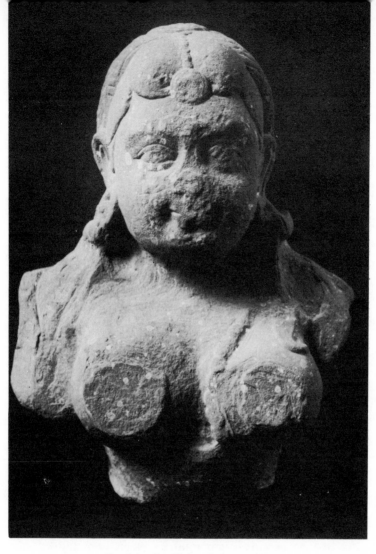

Female bust from Mathura. 2nd century A.D.

At Amaravati the compositions are iconographically more complicated than those at Gandhara or Mathura. The human figure attains great importance and the reliefs are deeper with greater contours. Themes are drawn from the life of the Buddha and the *Jatakas*. Group figures are sculpted on a number of planes and attempts are made to produce illusions of great depth. Later, in the 3rd century A.D. sculpture changes mood, with intertwined and interlaced figures formed in wild and frenzied movements.

The hair of the Buddha images is represented by snail-shelled curls. The lines of the drapery seem related to Mathura, but a peculiarity of the Buddha figures from Amaravati and the area is a heavy fold at the bottom of the outer garment, where it falls above the ankles. The Amaravati style extended to Sri Lanka through commercial and religious missions, although Buddhist images in the Andhra style have been found as far away as Dong-Duong, in Indo-China.

The golden age of Indian art was the Gupta period, which, for the purpose of description, we can take to extend from the 4th to the close of the 6th century A.D., although a strong Gupta influence continued to be felt until the 8th century A.D. It was the Gupta ideal of the Buddha and Bodhisattva image that influenced all later Buddhist art throughout the Buddhist world, even Japan.

By the beginning of the Gupta period, sculptors had mastered the plasticity of form and were able to concentrate on imparting qualities missing from earlier works, injecting what can perhaps best be termed a sculptural breath of life. It was a period of interaction between literature and the arts, which resulted in a canonical basis for many of the later images and created new aesthetic ideals. Art became, in fact, the vehicle of both intellectual and spiritual concepts. The human figure was all-important in sculpture and painting. It was supreme, superceding all other decorative motifs. In this way the human form was almost superhuman, an expression in visible form of invisible concepts. It was a modification of realistic form to express abstract ideas.

By this time, the two schools of Buddhism had formed, the Hinayana had moved southwards while the Mahayana, the Greater Vehicle, reigned supreme in the north.

As the figure became all important, it took on the primitive rhythm previously attributed to the many botanical motifs which surrounded the figures of earlier schools. It was, perhaps, this rhythm which supplied the figure with its vitality. Botanical motifs were still used, but they became secondary, although still an important aspect of decoration.

Images of the Buddha were carved with an expression of supreme spiritual calm, which emanates from the sculptures unlike any other figures carved before or after the Gupta period. Simplicity of form was all-important, anything that interfered with this was removed, including drapery which was reduced to near transparency, all folds clinging to and emphasising the anatomical form.

Sculptures of the Buddha of the Gupta period should be looked on

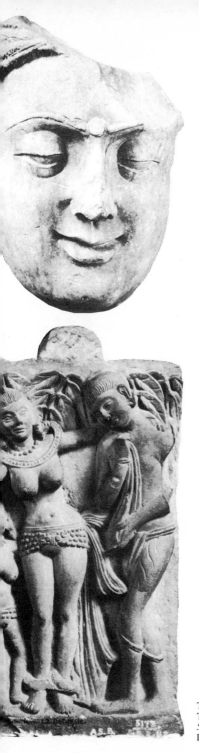

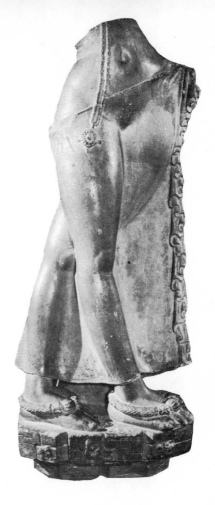

Top Left: *Stone head from Mathura. 3rd century A.D.*
Top Right: *Fragment of a stone sculpture of a lady. Mathura, 5th century A.D.*
Left: *Mithuna scene. Mathura, 2nd century A.D.*

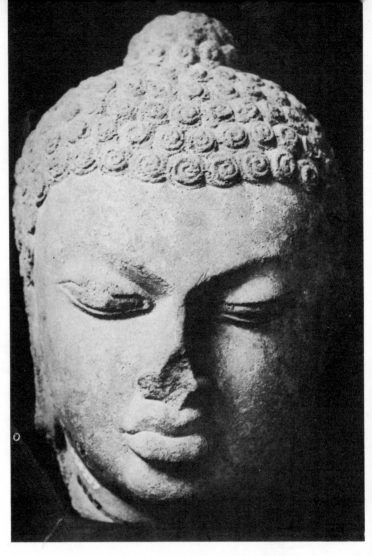

Stone head of the Buddha from Sarnath, 6th century A.D.

as images in the true sense of the word. They conformed to canons and they were sculpted in certain fixed poses dictated as *asanas*, *mudras*, or *hastas*, formulated to symbolise various attitudes. The *dhyanamudra*, for instance, often associated with Buddha images, is a gesture of deep meditation. The *bhumisparsa mudra* is associated with Enlightenment and the *dharmacakra mudra* signifies the turning of the Wheel of Law as the First Sermon in the Deer Park at Sarnath.

The two great centres of Gupta sculpture were at Mathura and Sarnath. At Sarnath, the Chunar sandstone, first used during the Mauryan period, was used to make numerous figures of Buddhas

and Bodhisattvas that decorated the stupas and viharas. Most of the Sarnath Buddhas have an almost abstract appearance, produced by over-simplification of the surfaces. One of the most beautiful aspects of these images is the contrast of the simplicity of the figures with the intricate carving of the halos.

Perhaps one of the greatest Gupta sculptures was found at Sarnath. It shows the Buddha seated in a yoga posture, his hands turning the Wheel of Law, the *dharmacakra mudra*. This superb work

Bronze figure of Buddha, Kashmir, 8th century A.D.

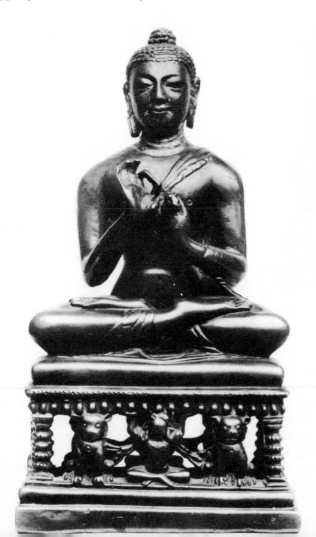

of art preserves the simplicity of the figure, contrasting with the background slab which is intricately carved.

The Buddhist sculpture of the Gupta period was carved by sculptors also versed in the art of carving Hindu images, for the Mahayana Buddhism of this time was very little different from the various sects of Hinduism. Hinduism has itself absorbed many Buddhist ideas, a fact which eventually led to the disappearance of Buddhism from the land of its birth. This did not finally happen until the close of the 12th century, when thousands of Buddhist monks were slaughtered by the invading Muslim armies.

The Gupta style developed at Sarnath and Mathura spread, both within the Indian sub-continent and elsewhere in Asia. In the Deccan it blossomed in the sculpture carved at some of the great cave temples of Ellora and Ajanta. At Ajanta, a centre of Buddhism from early times, cave monasteries and temples were excavated out of the hillside. Here, apart from the superb sculptures, magnificent cave paintings decorate some of the walls and ceilings. These temples span many centuries and clearly show how the style continued and developed several centuries after the Gupta Empire had ceased to exist. Here, too, the change to more ritualistic and dogmatic trends in Buddhism can be seen. Chapels were dedicated to the Bodhisattvas Avalokitesvara and Tara, and massive stone figures of Buddha seated in the European manner, sometimes with attendant Bodhisattvas were carved out of the rock. They have an air of supreme spiritual calm and detachment, and yet, have a presence which pulsates with compassionate humanity. There are scenes of Sakyamuni's temptation by Mara and his *Parinirvana*—the great release.

Ellora has similar monasteries, and sculpture, but no paintings. The colouring of the paintings at Ajanta is superb, and makes us lament the loss of such a majestic art, for the Ajanta paintings are the best preserved of this early art in India. The caves at Ajanta preserve frescoes dating from approximately the 1st century A.D. to the 7th century A.D. With the exception of a small lapse, they range over six centuries. The cave temples themselves span an even greater period.

The earlier works bear some resemblance to the sculpture of Amaravati, Bharhut and Sanchi, a fact which shows that here we have no primitive beginning, but a mature art form, indicating that there must have been many earlier paintings at other sites, which, alas, have been lost to us. The compositions are masterful. The painting is simple with bold vigorous lines. The treatment of the figures is delicate and executed with great skill. The hands are extremely

expressive. The predominant colours are red, yellow ochre and green. Other fine paintings of the early Buddhist school have been found at Sigiriya in Sri Lanka.

Apart from sculpture and painting, fine Buddhist bronzes were made, but few except the large examples have survived. These are similar in style to the stone sculptures of Sarnath and Mathura. A colossal bronze statue of this period was found at Sultangunj, and is now in the Birmingham Museum, U.K.

Some of the finest Buddhist bronzes came not from the Gupta period, but later, in the 10th century from Nagapattinam in South India where a fine series of rather stylised Buddhist bronzes were produced. At about the same time, figures of the Bodhisattvas were being made during the Pala period in Bengal and Bihar, but generally, because the decline of Buddhism coincides with the period when bronze sculpture in India was beginning to come of age, Indian Buddhist bronzes are rare.

To the Pala and Sena periods (A.D. 730–1197), also belongs the finale of Buddhist sculpture in India. In eastern India the effect of the Gupta period was felt for some time and certainly had a marked influence on Pala art. Under the Palas, however, Buddhism gradually assimilated aspects of Saivism and Vaisnavism (the worship of Siva and Vishnu respectively), until in the 12th century Buddhism finally disappeared from the land of its birth. The last great centre of Indian Buddhism was at Nalanda in Bihar, where there was not only a great university complex, but also a major artistic centre.

After the death of Buddhism in the north, Pala ideals of Buddhism shifted to Nepal and Tibet, while in South India, where Buddhism had similarly lost its hold, the seed of truth passed to the Resplendent Isle, Sri Lanka.

6 SRI LANKA

Buddhism has been a living and vital force in the island's history for 2,200 years. There are legendary claims to make the association with Buddhism even longer, for it is recorded in the Chronicles that the Buddha thrice visited the island, but the circumstances are purely mythological.

It was during the reign of Devanampiya Tissa (247–207 B.C.) that Mahinda, son of the Mauryan Emperor Asoka, converted the Sinhalese king to Buddhism, and thereby the island. Later, Mahinda's sister, Theri Sunghamitta, established a nunnery on the island. Today, although there are countless male members of the *Sangha* in Sri Lanka, there are no female orders. Asoka's daughter also brought with her a sapling from the original Bodhi Tree at Bodh Gaya under which Sakyamuni had obtained Enlightenment. The tree was planted in the island's first capital, Anuradhapura, where it still lives, the oldest historical and religious tree in the world. When the original tree at Bodh Gaya began to die, a sapling from Anuradhapura was planted to ensure the continuance of the unbroken link with the Bodhi Tree. Another sapling of the Anuradhapura Tree has been planted at Sarnath.

Early Sinhalese sacred architecture, while having definite affinities with Indian prototypes, have some features more in common with those of Indo-China. That is not to say that there was strong South East Asian influence in Sri Lanka, but that the opposite is true. These

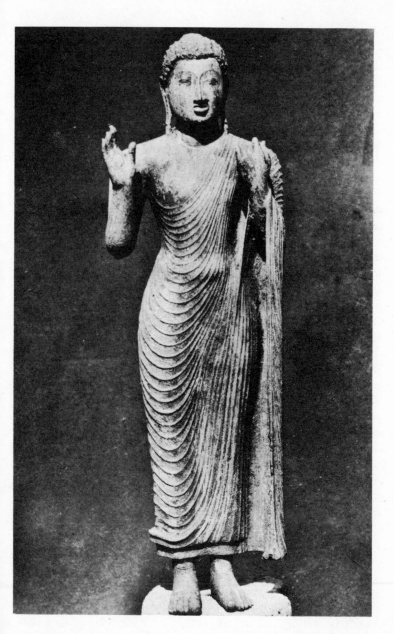

Bronze figure of the Buddha from Medawachchiya, Sri Lanka. c. 4th century A.D.

Indian sculptural and architectural ideas which penetrated the island were slightly modified and re-exported. In sculpture, the affinity with the Late Andhra sculpture of Amaravati is clearly apparent. The earliest of the Buddha figures date to around the 2nd to 3rd centuries A.D.

There has always been a very close connection between India and Sri Lanka from very early times, Indian artistic influence lasting in fact until the 13th century. The relationship between the two countries has, however, not always been friendly, for many times during Sri Lanka's colourful history it has had to contend with attacks and incursions from the Tamils of South India. Anuradhapura, the first capital, was taken in the 8th century and Polonnaruwa, the second capital, fell in the 13th century. Buddhism, however, entered the country on friendly terms and has remained a vibrant and living religion, most Buddhist art in Sri Lanka being inspired by the simple spirit and philosophy of Theravada Buddhism (Hinayana).

The classical age of Sinhalese Buddhist art belongs to that part of the Anuradhapura period that lasted from about the 2nd century to the 6th century A.D. The Chronicles, in fact, record that the Anuradhapura period extends from 437 B.C. to A.D. 1017. The style can be compared with contemporary Indian styles such as those of Bharhut, Sanchi, Mathura and Amaravati, all centres of Buddhism as well as art, while the later period clearly shows affinity with the Gupta style, although it may well be that the earliest Sinhalese Buddha figures owe their inspiration to Mathura rather than to Amaravati. As well as Buddhist influences, Hindu influences from south and south-east India were also felt.

Comparison of the Sinhalese Buddha statues with those of Amaravati reveal that the drapery is completely in the Amaravati style, with garments represented by ridges and incised lines. They also have a large billowing fold at the bottom of the garments, which is characteristic of the South Indian style.

The Anuradhapuran images have a kind of hieratic quality; a quality they owe to their massive proportions and rigid pose. They seem to have a grandeur reminiscent of the early figures at Mathura. Sculptures of the seated Buddha of the early period have a fine abstract quality of form, and an air of serenity and dignity. Masterful reliefs of *dvarpalas*, or gate guardians in the form of nagas are notable examples of Anuradhapuran art.

At the end of the 6th century A.D. the practice of carving large statues of the Enlightened One out of the living rock of cliff faces became the vogue. A few fine examples survive, but perhaps the most

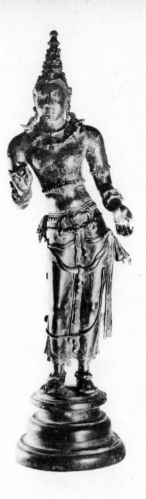

Bronze figure of a Bodhisattva. Anuradhapura, 6th century A.D.

Stone sculpture of a female diety (Tara?). Anuradhapura, 4th–5th century A.D.

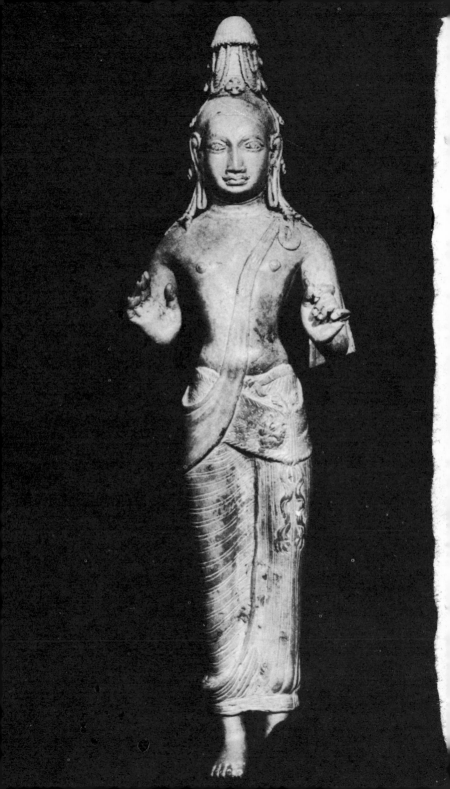

The 'moonstone' from the entrance to the 'Queens Palace' at Anuradhapura. c. 7th century A.D.

Left: *Bronze figure of a Bodhisattva. Giridara Gampaha. c. 7th century A.D.*

Façade of the Kanthaka Cetiya, Mihintale. c. 2nd century A.D.

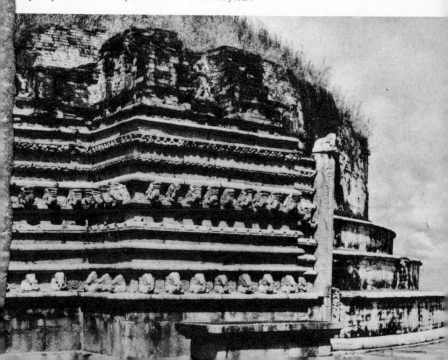

inspiring is a trilogy of three figures at the Gal Vihara at Polonnaruwa, which date to the 12th century. Although they do not belong to the Anuradhapuran period, they have a primordial grandeur which still echoes of Amaravati, both for their supreme abstraction and for their monumental concept. The smallest figure on the left of the group is in meditation, while at the far right is the largest figure, the still, dignified form of Sakyamuni at the moment of his *Parinirvana*. Besides him stands a solemn, yet detached figure that has been taken to be the Enlightened One's faithful disciple, Ananda. One recalls the Buddha's words to Ananda before he died.

'Those who, either now or after I am dead, shall be a lamp unto themselves, relying only upon themselves and not seeking external help, but keep to the truth of their own lamp, seeking only the truth for their salvation, not looking to anyone but themselves for help. It is they, Ananda, who shall reach the topmost height.'

Whether the standing figure is that of the mourning Ananda, we shall never know, for the three figures could equally well be interpreted as the Great Meditation and Enlightenment, the Teaching and the Ministry, and the *Parinirvana*—but then what does it matter? What matters is that they are there, they stand as a testament to the ancient Sinhalese devotion to the Middle Way and to the artistry of the island people.

As well as the earlier elements mentioned, the art of the Polonnaruwa period includes bronzes showing Gupta artistic influence, an influence which can be seen from the 7th century onwards and is still evident today. During the 3rd century A.D., Mahayana doctrines penetrated Sri Lanka and during the reign of Voharika Tissa (A.D. 214–236) influenced the monks of the Abhayagiri monastery. Although suppressed by the rulers, they continued to gain support until King Mahasena (A.D. 276–303) actively supported and promoted the doctrine, and even went so far as to destroy the buildings of the Hinayana centre, Mahavihara. Eventually, public opinion forced him to change his ways, and he later restored the buildings. Nevertheless, Mahayana principles and art were introduced to the country at this time, thus figures of the Bodhisattvas, especially Avalokitesvara (compassion), and Manjusri (wisdom) can be found. They were made in both stone and bronze. Generally later in date than the 3rd century, examples have been found dating from the 5th to 8th centuries and even later from the 12th to 14th centuries.

A masterpiece of Sinhalese Mahayana art is a little metal figure of the seated Tara, now in the Columbo Museum. Just over 15 cm

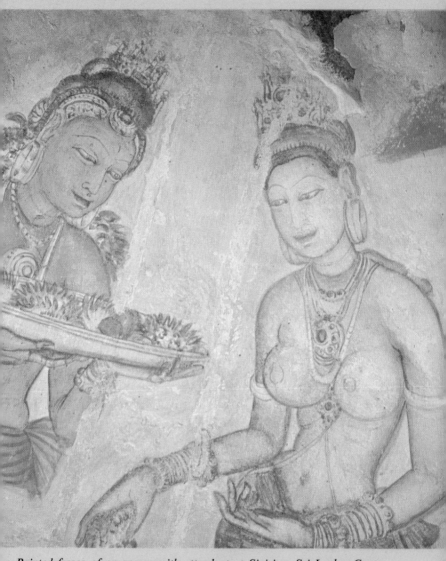

Painted fresco of an apsara with attendant at Sigiriya, Sri Lanka. Gupta style, c. 477–495 A.D.

Overleaf: *Sculptured head of a Bodhisattva from Seruvilla, Sri Lanka. 5/6th century A.D.*

Overleaf opposite: *Seated figure of Tara from Kurunagala, Sri Lanka. Silver and brass, 5/6th century A.D.*

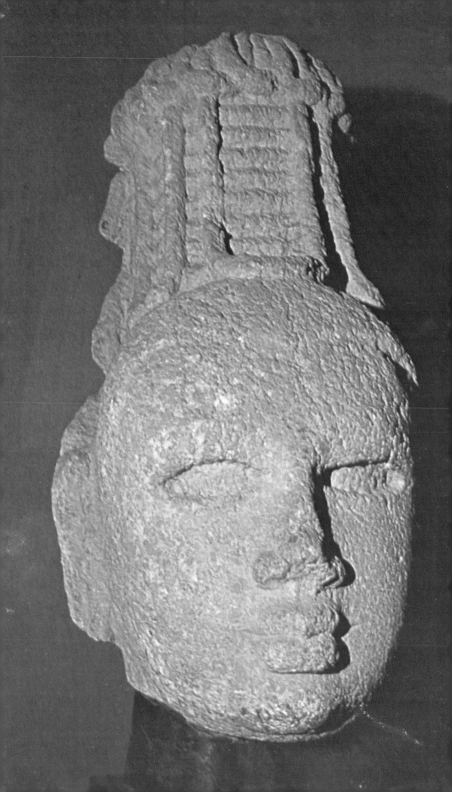

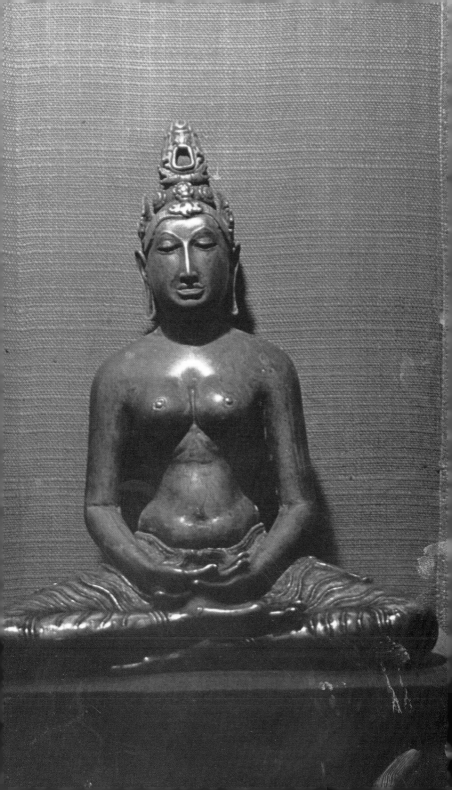

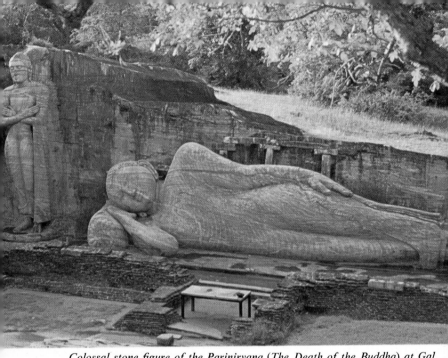

Colossal stone figure of the Parinirvana (The Death of the Buddha) at Gal Vihara, Sri Lanka. The standing figure to the left may be Ananda. The main figure is 45 feet long and the standing figure 23 feet high. 12th century A.D.

Close-up of the colossal stone sculpture of the Parinirvana at the Gal Vihara, Sri Lanka. 12th century A.D.

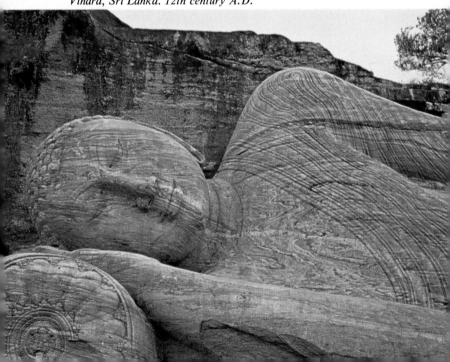

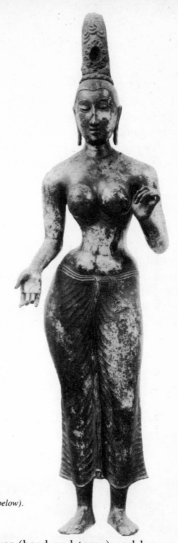

Gilt-bronze figure of Tara or Pattini Deva (see text below).

(6 inches) high, she is made of silver (head and torso) and bronze (drapery). It was found near the Gangarama Vihara, Talampitiya, N.W. Province. Another really lovely gold and bronze figure, which has been identified by some authorities as a representation of Tara, is in the British Museum, London. Standing approximately 122 cm (4 feet) high, the figure was found some years ago between Trincomalee and Batticaloa. The figure has been identified as Pattini Deva, Goddess of Chastity, and controller of diseases. Its date is almost as arbitrary as its identification, for although the figure shows Gupta artistic trends of the 5th century and can be compared with the *apsaras* of Sigiriya frescoes, which if a valid comparison, may date it to the 6th–8th century, the British Museum prefer to date it to the 10th–11th century.

Fine bronzes of the 10th century have been found near the capital of Anuradhapura. A miniature pair of feet in bronze show the same casting technique used to make the massive Buddha statue found at Sultangunj, in India. This figure was cast in copper in two layers on to a core composed of a mixture of clay, sand, charcoal, and rice husks. The feet from Sri Lanka differ in that the core is of iron. In both cases the first layer was moulded directly on to the core and in the case of the Sultangunj Buddha, was held together by iron bands. The outer surface was then probably cast over the first layer by the cire perdue method. The whole image seems to have been made in different sections. The normal method for producing bronzes in Sri Lanka was much the same as in India, the cire perdue or lost wax process. The original model is made in wax, covered in a composition and then heated to drive off the wax. The hollow mould thus formed is filled with molten bronze, and when cool, broken open, to reveal the bronze cast, which is then finished by hand. Thus, only one copy can be made from one wax original. The way around this is to cast the wax matrix from a sectional pottery mould—this was done in later figures of the 18th and 19th centuries when a number of figures of the same deity were required; in comparison to the earlier works, they were virtually mass-produced.

The artists of Sri Lanka have, over the years, created many wonderful examples of metal sculpture. In quality and style, they

Kumara pokuna, Polonaruwa, 12th century A.D.

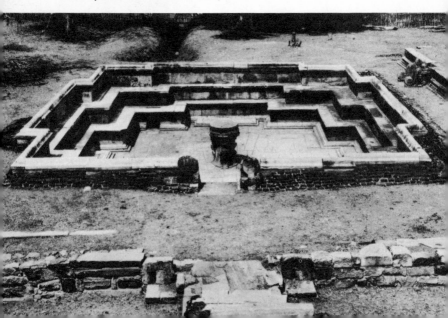

must be compared with the bronze art of the Pallavas and Cholas of South India, for the influence from India is especially noticeable in metal art. Some of the bronzes found in Sri Lanka are so similar to the South Indian ones that they may well have been cast there. Others differ in a way which is uniquely Sinhalese, and only direct comparison between the bronzes of the two countries will show the subtle differences inherent in the images of the Spice-Island.

Buddhist monks from Sri Lanka travelled far and wide. During the reign of Sirimeghavanna in about A.D. 303, due to the king's good relations with Samudragupta of India, a monastery was erected at Bodh Gaya, specifically for the use of visiting Sinhalese bhikkhus, on pilgrimages. In addition to the pilgrimages to the holy places in India, the Sinhalese sent out religious missions to other countries in the East. In the 5th century, three missions found their way to China, the first of which carried a jade image of the Buddha. The first two missions to the Chinese court were made during the reign of Mahanama (A.D. 410–432) and the third, during the reign of Dhatusena (A.D. 459–477). The female Buddhist order from Sri Lanka is also said to have established an order in China. All in all, this period in the island's history was marked by extensive relations with many countries, due mainly to sea-borne trade. It was at the hub of trade activity, with contacts as far afield as Persia in the West and China in the East. Contacts with these countries continued over

The lotus pond at Polonaruwa, 12th century A.D.

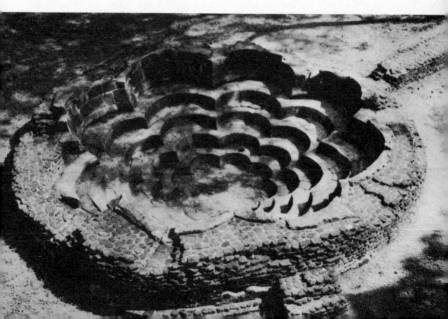

the centuries to a greater or lesser extent.

Buddhism in Sri Lanka has not always progressed unimpeded. Many times in her history, Buddhists were penalised for their beliefs and the *Sangha* persecuted or purged. After these occasions, the island had to resort to importing monks from the countries of South East Asia. Thus, Sri Lanka not only exported influences but also re-imported them, sometimes in modified form, and occasionally with South East Asian trappings, and ideas.

During the Polonnaruwa period, after his victory over the Cholas of South India, during which time Buddhism had been neglected, King Vijayabahu (reigned A.D. 1055-1110) petitioned the King of Burma to send learned and pious monks to Sri Lanka, so that the *Sangha* could regain its position in the country. A similar event occurred during the Kandy period (1597-1815) during the reign of Sri Vijiya Raja Simha, when the king asked the King of Thailand (Siam) to send bhikkhus so that the *upasampada* ordination could be held. His request was granted and in 1753 twenty bhikkhus arrived in Sri Lanka. A number of monks were accepted to the high ordination and Saranankara was appointed the Sangharaja (head of the *Sangha*) of Sri Lanka. With his help Buddhism, which had suffered oppression for a while, re-established its supremacy on the island. The importation of bhikkhus from Thailand was, in a way, a return gesture, for in 1361 a Sinhalese Sangharaja had been invited to Thailand (Siam) to organise the *Sangha* there. During this time, monks from a number of parts of South East Asia, including Cambodia, Thailand and Burma received religious instruction and ordination in Sri Lanka. The island was in fact regarded as a great religious centre of Buddhism. Offerings were sent by Burmese monarchs to the Sacred Tooth Relic, and it is even said that Kublai Khan, the Chinese Emperor, sent a mission to Sri Lanka in 1284 to try and obtain the Tooth, Bowl and Hair relics! Needless to say, he did not succeed!

At other times, Sri Lanka was more forceful in her influence, as in 1164, when Parakramabahu sent a penal mission to Burma against Alaungsithu, the Burmese king, who had ill-treated Sinhalese envoys and captured Sinhalese princes on their way to Cambodia. The Sinhalese campaign was successful, capturing several Burmese towns, eventually withdrawing after a treaty was signed.

A superb sculpture of Parakramabahu stands to the north of Potgul-vihara, at Polonnaruwa. This colossal figure is a masterpiece of Sinhalese art, it has a feeling of lightness which releases it from its great bulk and reminds one of the bronzes of the Chola period

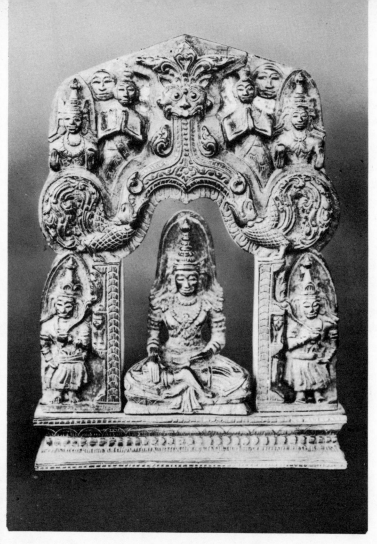

Bronze figure of Maitreya. Sri Lanka, 18th century.

of South India.

Apart from fine sculptures and bronzes, Sri Lanka had a wonderful school of fresco painting, closely allied with that of India. It may be especially compared with the Indian school that produced the magnificent frescoes of Ajanta.

The most spectacular paintings that have been preserved in Sri Lanka are those on the cliff face of the rock fortress of Sigiriya. Here, twenty-one life-size paintings of elaborately jewelled and coiffured figures have been preserved on the cliff face, protected by the rock overhangs. Painted during the reign of Kassapa I (A.D. 477–495) they are true masterpieces of Buddhist art. They are not

full-length but have been cut half-way by clouds. Some are naked above the waist and golden in colour, others have a breast-band and are darker in hue, they wear a bifurcated dhoti from the waist downwards. It has been suggested that the paintings depict ladies of Kassapa's court with their maids-in-waiting, going to worship at the temple of Pidurangala near Sigiriya. Others have interpreted the golden figures as princesses of lightning and the dark figures as cloud damsels, while yet another version simply labels them as *apsaras* or celestial nymphs.

The Sigiriya frescoes are strongly reminiscent of the Buddhist paintings at Ajanta, which were executed in the same technique. The colours are red and yellow ochre and green earth. Anatomically, the figures closely resemble the female reliefs at Amaravati and may echo the lost school of Andhra painting. In spite of these comparisons with India, they must be accepted as typically Sinhalese, especially in some aspects of the drawing and painting. The noses are unique, and they are of two types, one in profile, with the face in three-quarter view, and the other in three-quarter view, with the far nostril clearly delineated. These beautiful paintings have a charm all their own. The outlines have an open honesty with corrections to

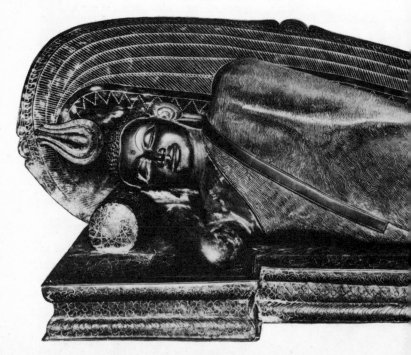

the contours and alterations to hand and breast positions clearly visible. The figures are almost plant-like in conception with slender waists, well-formed, round breasts, and long, shapely arms, which terminate in exquisite hands.

Paintings of this period have also been preserved elsewhere in Sri Lanka, such as those in the cave at Hindagala, near Peradeniya. Others of later date have been preserved at Mihintale and Anuradhapura. A group of fine paintings of the Polonnawura period have been found at the Tivanka shrine in the second capital. Dating from the late 12th century to early 13th century, they drew their subject matter mainly from the life of the Buddha and the *Jatakas*. Again, the well-balanced compositions and tonal effects in yellow, green and red, remind one of the great Indian classical tradition of Ajanta, but they somehow fail to equal the Ajanta model. Nevertheless, these paintings are the last in the style to echo the great days of Ajanta. Mahayana doctrines are clearly present in the scene of the Bodhisattva in the Tusita Heaven. During the mid 12th to 14th centuries, Mahayana doctrines became very popular, especially the worship of the Bodhisattvas Maitreya and Avalokitesvara (Lokesvara-natha).

Hinduism, which did not have a great deal of influence during the

Bronze figure of the Parinirvana. Kandy, 18th century.

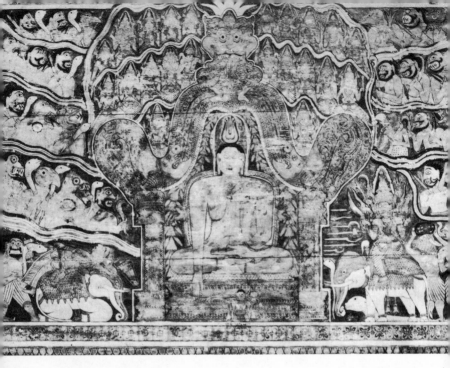

Buddhist painting of the Mara Yuddhaya or Buddha's victory over the forces of evil. 18th century A.D.

early periods, became a strong force at varying times during the Polonnawura period and thereafter remained present on the island. Hindu temples were erected and a number have been uncovered in the jungles of Polonnawura. These date to the period of the Chola occupation in the 11th century, but were desecrated in the 13th century by Parakramabahu II. The style is the same as the South Indian Chola. Islam was also present on the island, though mainly at the principal ports, while Christianity was introduced by the Portuguese in the 16th century.

Before leaving Sri Lanka, we should note the form of the Buddha image which developed on the island, and which became peculiar to it. The main features which distinguish these examples from others is the continued use and exaggeration of the lines of the drapery. These are greatly incised in a wave-like form. Unlike some of the Indian images, where the Buddha is shown as supreme Lord of Compassion, the Sinhalese artists have treated him as a human being, if an extraordinary human being, in a state of perfect peace and on the highest spiritual level. Nevertheless, the figures are somewhat rigid and stylised, sometimes even angular. On the head, the *usnisa* has become a high, stylised flame. All these are features which can be traced back to Indian originals, but which have become greatly exaggerated in their later artistic isolation from a non-Buddhist India.

7 SOUTH EAST ASIA

In Indonesia, Buddhism and with it Indian artistic influence first affected Java, then Sumatra. This took place some time between the 3rd and 6th centuries A.D., and is marked by the importation of Indian works of art, brought to Indonesia by Indian merchants from the Andhra Empire, who founded settlements there. Merchants from these settlements carried on extensive trade with Burma, India, Indo-China and even China. With the rise of the Gupta Empire, Indo-China received additional immigrants from some of the lesser kingdoms of India, which were being moulded into the Gupta Empire.

These two factors combined with the Indonesian culture and tradition to evolve a complex social and political structure, and an indigenous art, modelled at first on the Indian pattern, but which from about the 8th to 13th centuries blossomed into the mature and unmistakable classical style of the archipelago. In the interval from the 7th to 8th centuries, there was a period of experimentation on the Indian original, and a perfection of the artistic language.

The doctrine at first was Hinayana, but from about the first part of the 7th century Mahayana doctrine was introduced, strongly influencing the developing Buddhist art. The Vajrayana sect of Mahayana Buddhism was also introduced and gained strong ground. This was perhaps due to its close affinity with Hinduism, which was also present in Java, and by its ready acceptance by the indigenous

population, whose beliefs were primitive but who could associate with the mystic and ritual elements of the doctrine.

Indian influence in politics was firmly felt. The Sailendra dynasty, which ruled Java from A.D. 778-864 came originally from the vicinity of Amaravati, thus it is natural to see elements of Amaravati art in the Buddhist art of Java. Other similarities with Gupta art are due to influences from Ajanta and Ellora, and from the 8th century from the Buddhist centre of Nalanda in north-east India. It was from there that Vajrayana elements passed into Javanese Buddhist art and culture, for there was a monastery at Nalanda, specially for the use of Indonesian students. Nalanda was also a centre from which Vajrayana ideas and arts were first introduced into Nepal and Tibet. It is not unusual then to notice some similarity between Nepalese and Tibetan bronzes and Vajrayana accoutrements with those of Java. The greatest example of Indonesian Buddhist art and architecture, Borobudur, in fact combines in its grand plan the early Buddhist architectural form of stupa, with that of the *mandala* of Vajrayana Buddhism.

Borobudur is a unique and marvellous structure. Situated in the central plain of Java it is the largest Buddhist structure in the world. On its many terraces is the finest collection of classical Javanese sculpture, which shows not a little influence of Gupta India. There was so much interaction between India and the countries of South East Asia at this time, that it is natural to see such strong influences. This influence exerted itself in many ways through Indonesian travel to India and vice versa; from the importation of Indian works of art and artisans, through subconscious influence brought about by word of mouth, and by descriptions in the iconographic manuscripts which entered the country. Nevertheless, the Buddhist art of Indonesia is quite unique and readily distinguishable from the rest of the Buddhist world.

Borobudur is essentially the work of the Buddhist rulers and is not a monument born out of indigenous inspiration, which was different in character. The structure is not a building in which one enters to worship, for there is no inner space. There is no place as such where devotees can worship, it is instead a centre for pilgrimage and, like the traditional stupa, was meant to be circumambulated by the pilgrim. Borobudur is built up by a number of terraces, each in its turn meant to be circumambulated, the pilgrim progressing upwards as he goes. Each terrace contains the most magnificent reliefs of continuous narrative sculpture. The monument, which extends in height to 35 metres or 114½ feet, can be clearly divided into three parts, plat-

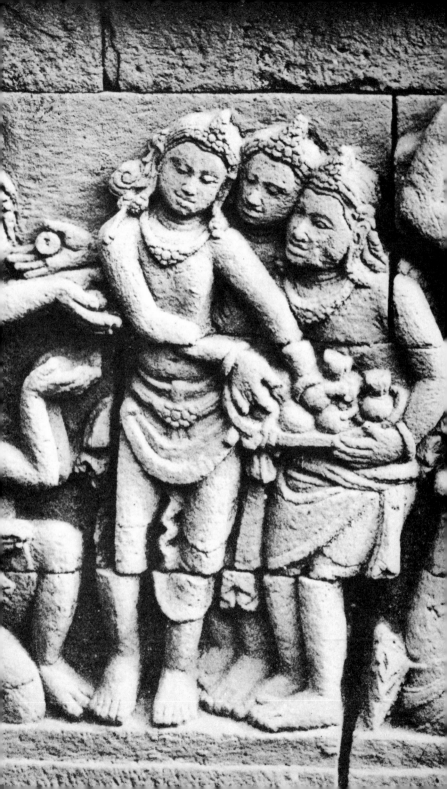

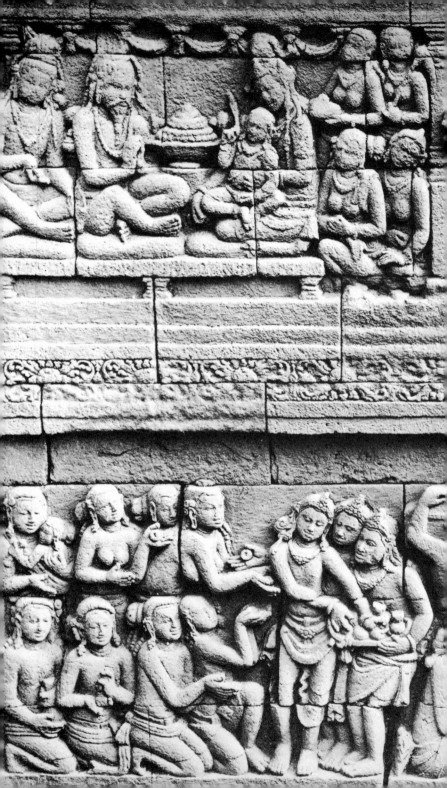

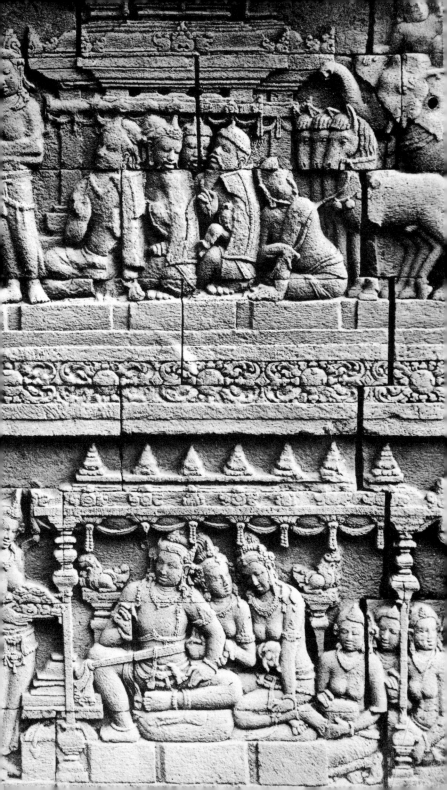

Some of the miniature stupas on the terraces at Borobudur.

One of the seated Buddhas from Bor

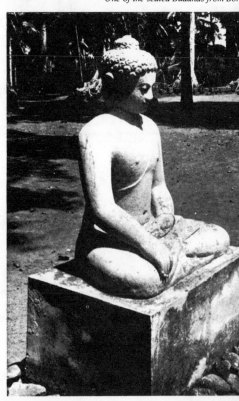

form, terraces and surmounting stupa. There are five terraces, each of which diminishes in size and height as it progresses upwards. On to this is a superstructure in the form of a stupa which rests on three circular platforms surrounded by small perforated stupas. It is difficult to appreciate the huge size of the monument. There are literally thousands of reliefs, hundreds of niches with seated Buddha statues, and nearly fifteen hundred small stupas.

The reliefs are divided into two types, individual decorative panels —these number about eleven thousand two hundred and continuous narrative panels—these are arranged in eleven rows which surround the monument. There are approximately one thousand four hundred and sixty of these, which run to a total length of 3,000 metres (9,843 feet)! The first reliefs at the base (now covered) illustrate the law of *Karma*. The other ten rows illustrate the life of the Buddha, and stories from the *Jatakas* and *Avadanas*. The decorative reliefs are figuratively Gupta in style.

The Buddha statues are carved according to the Mahayana concept of the five Dhyani Buddhas. All the Buddha figures represent Dhyani Buddhas and each can be ascribed to one of the five cardinal points, east, south, north, west or zenith, according to the *mudra*, i.e. a position of the hands.

Although Borobudur is unique in architectural form, the sculptures are distinguished only by their fineness, they are typical of central Javanese Buddhist art of the period. They reflect Gupta style, but in a way which is warm and human.

The monolithic and majestic grandeur of Gupta artistic ideas can, however, be seen in the three seated figures of Buddha the Teacher, with the Bodhisattvas Vajrapani and Avalokitesvara on either side, in the central chapel of Tjandi Mendut. They recall the seated Buddha figures of Ellora and Ajanta in India. Javanese sculpture has a great charm, it overcomes its austerity of line with a vibrant force of life.

Alongside Buddhism, Hinduism was always present, and so was its art. After the great period which produced Borobudur, Javanese Buddhist art continued to flower, but in east Java, Hinduism gained greater support and Buddhist art as such virtually disappeared.

There has been much discussion by scholars as to whether there were two ruling dynasties in Java, from the 8th to 10th centuries A.D., one Buddhist and the other Hindu. It seems probable, however, that they were one and the same with only the official religion changing. There has never been conflict between the two religions in Indonesia. The religious affinities of the ruler is marked by his

tracing his lineage back to some great Hindu or Buddhist ruler of Java. Thus, the Sanjayas who were Saivite (Hindu) traced their lineage back to Sanjaya, the great worshipper of Siva, and the Sailendras traced their lineage back to the Buddhist ruler Sailendra. We shall probably never know the real truth, for there is much contradictory evidence and theories. For instance, that the Sailendras came from near Amaravati in South India or even some place in Indo-China and the assertion that the Hindu rulers were of Indian-Javanese origin—both may be true, but the history of South East Asia is often vague. If we move northwards to Indo-China, i.e. present-day Cambodia, Laos, Thailand and Vietnam, the picture is no clearer, it even worsens, for the religious and cultural history of these countries is extremely complex. It is necessary greatly to simplify the picture if we are to see the part Buddhism played in their art and their part in the development of Buddhist art as a whole.

To put it simply, Indo-China may be divided into two, the line demarcating the two sections running north–south through eastern Indo-China. The area to the east of this hypothetical line, i.e. mainly Annam (present-day North Vietnam) was subject primarily to Chinese influence, and the area to the west of the line, reveals influence by way of various routes from India. This division between eastern and western zones did not prevent Indian influence reaching south China by the southern route, it simply took a detour around Indo-China by the maritime trade route—India, Indonesia, Funan and Tongking.

The art history of Indo-China may be divided into five phases. The first phase of which lasted from the first century A.D. to the mid 7th century, and is marked by two major cultural centres, one in the Chinese province of Tongking in the north east, the other in the south, called Funan by the Chinese. In both areas Buddhism flourished, though in Funan it shared its popularity with Brahmaniśm, which had perhaps the strongest hold on the people. In the 4th–5th centuries, though, Buddhism was almost equal in popularity. The culture of Annam, in the Chinese zone of influence, slowly became sinicised due mainly to Chinese cultural conquests. Tongking was an important crossroads for India-bound traffic, either by sea, coast or overland via Burma, and thus some Indian influence did penetrate but to no great effect.

In the south, Funan was greatly influenced by the art of Gupta India, and many of the figures of the Buddha in bronze, stone or wood, reflect Gupta or part-Gupta trends. On its decline, after the mid 6th century, Funan divided into two kingdoms, Dvaravati,

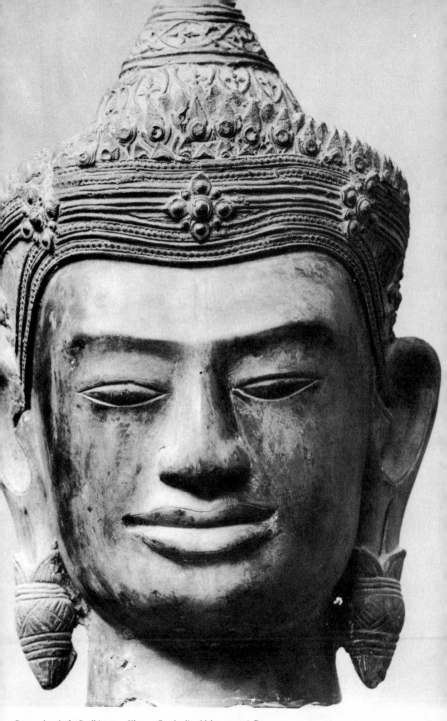

Bronze head of a Bodhisattva. Khmer, Cambodia, 11th century A.D.

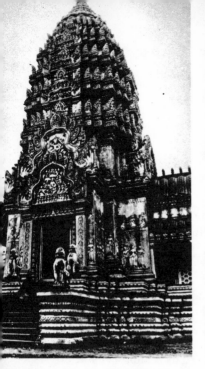

Two views of the ruins at Angkor Wat, Cambodia.

Left: *One of the temples at Angkor Wat. The face of Lokeshvara, looks towards the four directions.*

present-day Thailand in the north, and Khmer, in central and south Indo-China, incorporating the Cambodian state of Chen-la.

In spite of change, Buddhist art continued without a break, drawing its influence in the 6th and 7th centuries from India, Sri Lanka and Dvaravati. After this, a change is evident when the artistry becomes independent creating a style that has been called pre-Angkor. Mahayana Buddhism had, by this time, supplanted Hinayana, a fact which is reflected in the art. Buddhism, however, was not the primary religion, it shared its position with Brahmanism because the rulers were devotees of Siva along with Vishnu. Buddhism did not become a major religion in the area until much later.

Indo-China shared an ideology with Indonesia, that of the deified ruler. This was in accordance with Saivite principles. The ruler was thought of as an emanation of the God on earth, and thus was both ruler and god, in much the same was as in ancient Egypt. The cult was common to both Indo-China and Indonesia. On the death of a ruler, his remains were incorporated into a sepulchral temple which became a centre of worship. The idea was often assimilated into the Mahayana Buddhism of the area, and continued under Buddhist rulers. This happened in Indo-China when the Indonesian Sailendras extended their power to the Khmer kingdom, south

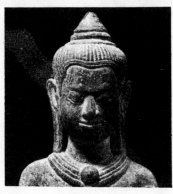
Bronze head of the Buddha. Khmer, 13th century A.D.

Indo-China, by the sea route via Indonesia. Mahayana was always linked with Hinduism.

One of the greatest styles of Indo-China is the classical style which developed in the Khmer Empire, from the 9th to the early 12th centuries. This art produced wonderful architectural and sculptural masterpieces, which, though mainly Hindu inspired, had a marked effect on Buddhist art. The principal monuments such as Angkor Wat, Bakheng and Bakong, are of Hindu inspiration. Khmer Buddhist art did develop, but it owed its Buddhist characteristics to Dvaravati. The principal phase during which Khmer produced the now famous heads of Buddha and Bodhisattvas can roughly be associated with the reigns of Yashovarman (889–900) and Surya-varman I (1011–1050). Buddhism gave to Khmer art a feeling of supreme compassion and mystic serenity, a quality which is completely missing from Hindu-inspired works. The Buddha and Bodhisattva figures have a sublime smile of inner peace.

Angkor Wat was constructed during the reign of Suryavarman II (1130–1150). It marked both the peak and the end of the great classical, mainly Hindu, art of Khmer. It also marked the end of Hindu influence. After this time, Hindu influence is only reflected as faint echoes and is not reinforced by major Hindu revivals.

The Bayon, possibly built during the reign of Jayavarman VII (1181–1220?), is typically Mahayana Buddhist, though still with overtones of the cult of the deified ruler, a fact indicated by the design of the temple. On each of the fifty-four tiers, the gigantic face of Bodhisattva Lokeshvara looks out in all directions. The face of Lokeshvara is that of the king shown as the incarnation of the supreme god. It is interesting to note that the idea of having gods portrayed in one's own image is today extremely popular with the rich Hindus of India, who have clay images of goddesses, which are in reality portraits of their wives or girl friends made for the annual *pujas*. This, of course, has no connection with the ancient practice as carried on in Indo-China and Indonesia, and is only mentioned

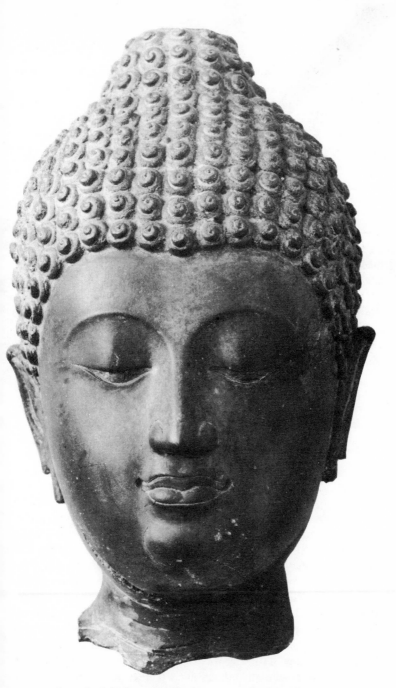

Bronze head of Sakyamuni Buddha, Chiengsaen, N. Thailand, 13th century.

here out of interest.

Bayon is an extremely important landmark in Buddhist art, for it shows the adaptability of Mahayana Buddhism—the central statue of the Buddha at Bayon for instance, is also a representation of the ruler. Thus, Hindu and local traditions have merged in the ever-flexible Mahayana concept of Buddhism.

In Champa, Mahayana art flourished, though only as a partial aspect of the religious art which was inspired by Hinduism and the cult of the divine ruler. One of the finest figures of the Buddha was found at Dong-duong, dating to about A.D. 300. It shows an extremely strong influence of Amaravati.

One of the bas-reliefs from an inner gallery of the ruins at Angkor Wat.

Later, the influence was Chinese, brought there by Chinese pilgrims on their seaward journey to India and by diffusion from the adjacent area. Chinese influence from Annam became very strong in the 11th and 12th centuries and had a major effect on Buddhist art. The period from the 12th to 13th centuries marks the gradual decline of Mahayana Buddhism in Indo-China and the re-establishment of Hinayana in the Theravada tradition. The Khmer people and later the Thais, originally worshipped in the Mahayana tradition but turned towards Hinayana. Whether this was due to social change or to spiritual development is not clear. Hinayana took a firm hold on the people, penetrating into every facet of their daily lives. This change naturally was reflected in the art. One can thus see the transition actually taking place. Khmeri styles continued but were changed by the Hinayana traditions of Dvaravati. One pecu-

114

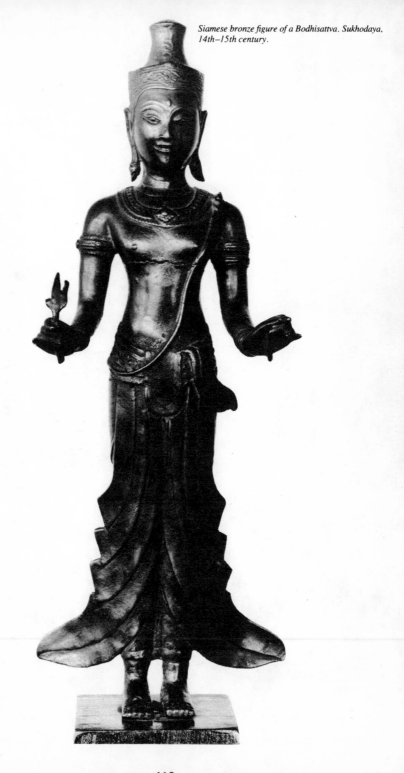

Colossal bronze Buddha in the ruins of Ayuthia, Thailand.

liarity remained, an echo of Mahayana ideals, and that is of the Buddha in 'Royal Robes' which actually gained in popularity. In Thailand, this style is the major form of Buddha image and is easily distinguished by its tall head-dress.

A major difference between Mahayana and Hinayana art is that in Hinayana, the doctrine was an obstacle in the development of figurative art. Unlike the Mahayana artists, those of the Hinayana could not draw on a pantheon of deities. In Indo-China, however, the development of Mahayana figurative art was to a great extent hampered by its association with the deified ruler. Thus, much of its iconography was a foreign import from India.

The Thais originally came from south China. Being driven out of that area, they headed south. By gradual expansion, they managed

The colossal figure of Buddha at Ayuthia. The figure in front of the Buddha gives some idea of the huge size of the image.

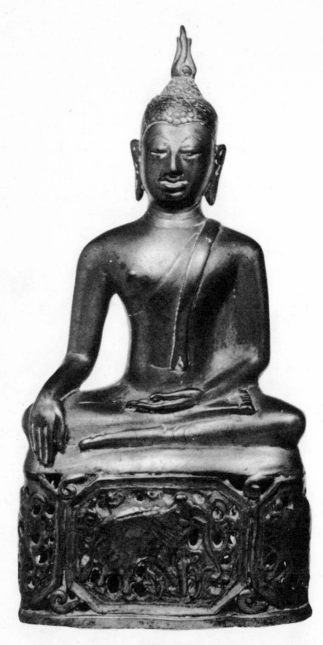

Bronze seated figure of the Buddha. Siamese, 16th century.

to secure themselves the part of Indo-China between the Khmer Empire and Burma. Their first kingdom was Sukhothai, and their second Chiengmai. Chiengmai is known for the typically 'Siamese' type of Buddha figure that developed there. The southward expansion of Hinayana was to a certain degree associated with the expansion of the Thais. By the mid to late 16th century, Mahayana Buddhism had completely disappeared both from India and South East Asia.

The Sukhothai period produced a unique style of sculpture formed by the merging of the post-Bayon art of Cambodia with that of the Dvaravati tradition. The typically Siamese form of the Buddha image mentioned earlier took on its mature form there during the 14th century, later spreading to become a model for all Siamese Buddha images.

Several regional types are, however, identifiable in the Chiengmai area. A distinctive style evolved during the 15th and 16th centuries, a fact which is underlined in a number of dated images. U-Thong in the south also produced its own regional style. These figures show a degree of Khmer influence. Bronzes were made in number during the 14th and 15th centuries in the Ayuthai area. Ayuthai was the capital of Siam from 1353 to 1767. In 1782 the capital was shifted to Bangkok. From this time, Buddhist art lost much of its vigour and creativity. The Buddha figure becomes increasingly schematised, a fact that is not alleviated by the elaborate decoration or enlargement of size. Nevertheless, the fact that Buddhism became a state religion created a demand for more and more art, bringing about the sort of secondary renaissance.

Before leaving the Buddhist art of South East Asia, mention needs to be made of Laos and Vietnam. Laos, on one hand falls into the Indian sphere of influence and from the 14th century absorbed ideas from Khmer and from Ayuthai. Vietnam, on the other hand facing China as it does, received its influence from that country. Its art is not outstanding and its beliefs are somewhat complicated by the fact that it absorbed ideas of Mahayana Buddhism as well as Chinese philosophy in the form of Taoism and Confusianism with its association with the worship of the ancestor—it even had its own brand of Zen or Ch'an Buddhism.

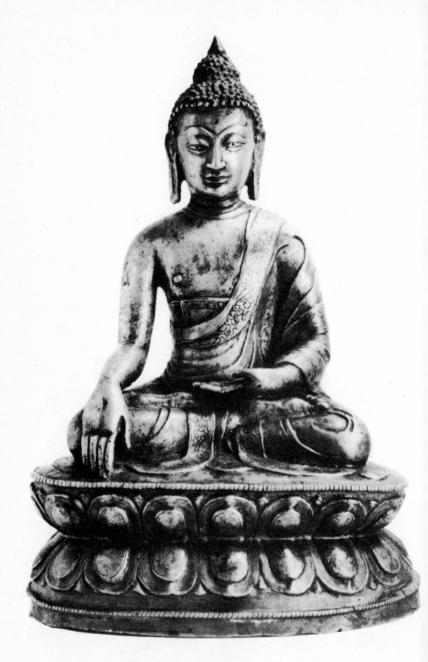

Tibetan bronze figure of Sakyamuni. 14th century A.D.

8 NEPAL, TIBET
AND CENTRAL ASIA

The Buddha, Gautama, was born in the Lumbini Grove in the Nepal terrai and the Buddhist Emperor Asoka erected a number of stupas on his mission to Nepal in 249 B.C. In spite of these early contacts with Buddhism, the religion did not enjoy widespread popularity in Nepal, and the country did not entertain the religion until relatively late in the history of Buddhism. Today though, while Buddhism has ceased as a living religion in India, it thrives in Nepal alongside Hinduism. There is no religious animosity in the country, and Hindu and Buddhist shrines are found side by side, with devotees of each religion visiting the temples of the other. In fact, Hindu images can often be found in Buddhist temples and vice versa. The very amiability of Buddhism and Hinduism which resulted in Buddhism becoming extinct in India, had the opposite effect in Nepal.

This interaction between the two religions goes back centuries, and there are records of a similar situation existing in the 6th century, when the Chinese pilgrim Hsuan-tsang visited the country. He recorded his surprise to find that Buddhist temples rubbed shoulders with those of the unbelievers. This long relationship between two religions had caused an association of artistry and artistic ideas. For those unused to the situation it can be very difficult to distinguish between the iconography of the two religions, even the architecture in some cases looks the same. This is perhaps natural when the same artists and craftsmen were responsible for producing the temples and images of both religions!

In spite of the great outward similarity between the two religions in Nepal, the fundamental difference in the attitude between Hindu and Buddhist remains. Buddhists have a reverence and compassion for all life which contrasts with the practice of the Hindus who, as part of their worship, regard animal sacrifice as a necessary ritual. This, in fact, sometimes involves the slaughter of a large number of chickens, goats, and buffaloes, especially during the festivals such as Dusserah.

Buddhism in Nepal, then, is and has been complicated by its association with Hinduism. It is also complicated to a certain extent by the physical geography of the country and by its political history. There is a mountain barrier both southwards between India and Nepal and northwards between Nepal and Tibet. The valley of Katmandu, the political centre of the country, is surrounded by mountains, which effectively reduces its contact with other countries. During periods of political antagonism between India and Tibet, she was at times completely isolated, while at other times receiving cultural influence both from the north and south. In the case of Tibet, the influence and diffusion was to a certain extent two-way.

Some of the terracotta supporting figures at the terracotta Mahabodhi temple at Patan, Nepal. 14th century A.D.

Asoka's so-called pilgrimage to Nepal in 249 B.C. may well have been a cover for his territorial ambitions, for it seems that he annexed the valley and incorporated it into his empire. Among the monuments that he erected, only a few earthen stupas remain, and those are probably later reconstructions. One of them is at Patan. The core of the Swayambhunath and Bodhnath stupas may also date to Asoka's time. History in Nepal is difficult to separate from legend. Thus, most of our early knowledge of Buddhism and its history is clothed in the blanket of mythology.

It seems certain, however, that the first sect of Buddhism introduced into the country was Hinayana, but this quickly gave way to Mahayana when the latter developed. It seems that Hinduism has always existed side by side with Buddhism, and even the earliest evidence points to the existence of Saivite temples next to those dedicated to Buddhism.

Tantrism in Nepal is very strong. This mystic and esoteric ritual belief is associated with both Hinduism and Buddhism. In Buddhism, it was practised by the Vajrayana sect—the 'Vehicle of the Thunderbolt'. The cult made its way to Nepal from the Vajrayana centres in Bihar, which is the adjacent state in India. Tantrism is

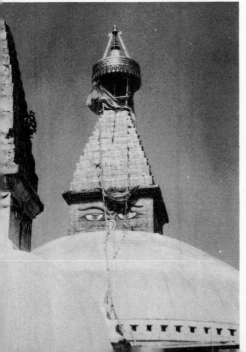

The Bodhnath stupa, Nepal, a centre of Tibetan Lamaism.

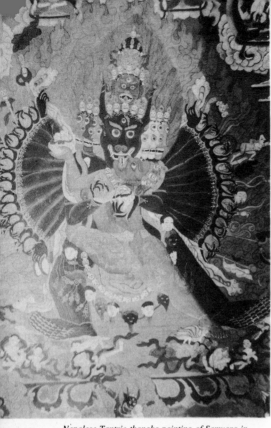

Nepalese Tantric thangka painting of Samvara in Yab-Yum. 19th century A.D.

very much alive in Nepal, and a great deal of Nepalese art has been inspired by its teachings. It is not an open sect, like other branches of Buddhism, for while it is possible for the masses to worship, the inner meaning to certain rituals, diagrams and verbal formulae is only divulged through teachers or *gurus*, and then only after years of practice. It is a Vehicle, however, on two levels, very much like other branches of Buddhism, but unlike other branches, where one can progress and see the teachings for what they are, i.e. religion or philosophy, the way in Tantrism is only open to one through certain doors, which are jealously guarded. Tantrism is more correctly termed Vajrayana (though not when applied to Hinduism). It is practised in Tibet and in Japan and for a certain period was popular in China.

The development of Buddhism in Nepal, the Himalayan kingdoms, Tibet and Central Asia, is extremely important. For Northern Buddhism, as we can call it, contrasts strongly with the almost puritanical development of Buddhism in the Southern school. In some cases, however, reference to Northern and Southern Budd-

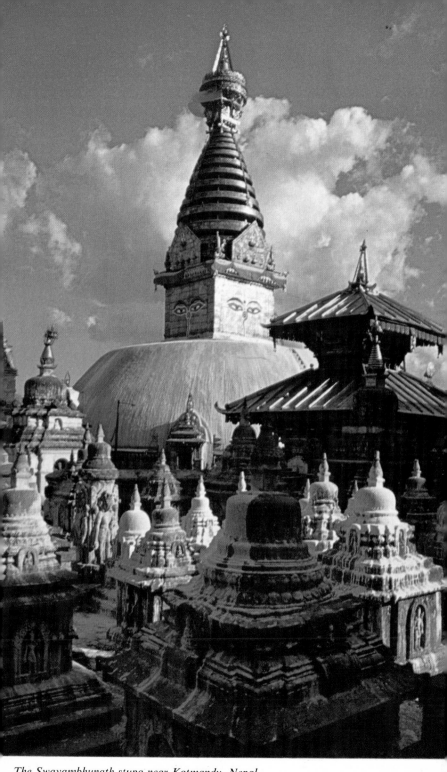

The Swayambhunath stupa near Katmandu, Nepal.

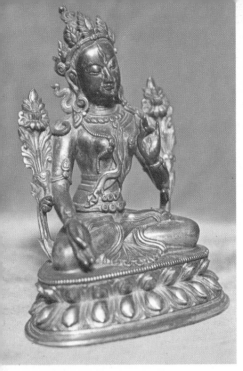

Tibetan bronze figure of Green Tara.
18/19th century.

Tibetan bronze figure of White Tara.
18/19th century.

The interior of the Royal Chapel at Gantock, Sikkim.

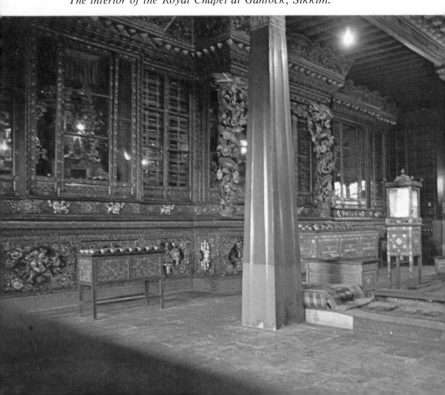

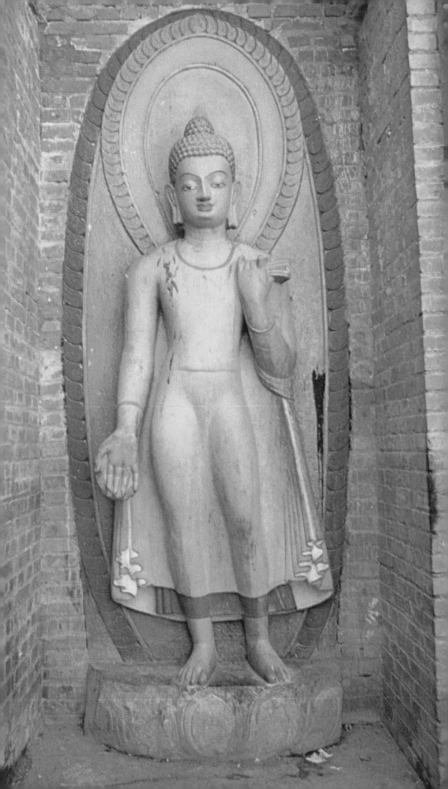

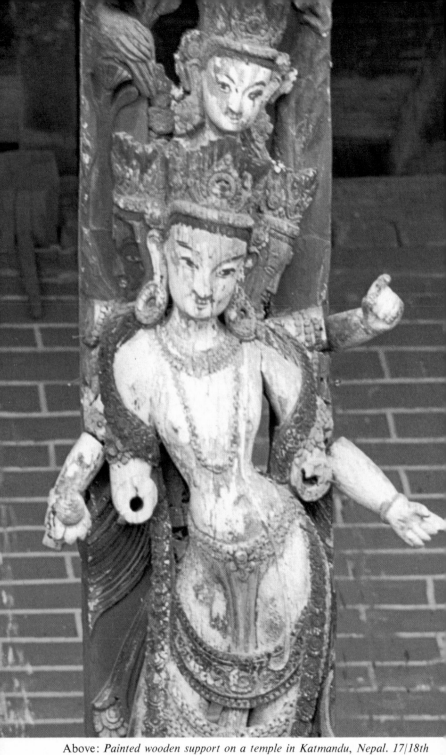

Above: *Painted wooden support on a temple in Katmandu, Nepal. 17/18th century.*

Previous page: *Painted stone sculpture of Buddha at Swayambhunath,*

hism can be very misleading, for as we have seen, both Mahayana and Vajrayana Buddhism had some influence on the art of Indonesia and Indo-China, which today is part of the area of influence of the Southern school. The modern definition of Northern and Southern Buddhism is that of Mahayana and Hinayana (Theravada).

The terrain and the people had much to do with the northern progress of Buddhism. While the Nepal valley is fertile, and warm in the summer, the surrounding mountains and the plateau is a cold, windy and inhospitable place. Tibet, the roof of the world, with much of the land lying between 10,000 and 20,000 feet, is also dry, with only about 25 cm of rain a year. There is, then, more affinity between the climate of India and Nepal than between Nepal and Tibet. This had an important effect on Buddhist art as it travelled northwards, for the wild, almost jungle exuberance becomes more severe, controlled, and what is interesting, warmer, i.e. warmer in human terms, in terms of refuge. Both Nepal and Tibet are lands of the gods, and as such have been centres of a vibrant and sacred art. Kirkpatrick, commenting on his visit to Nepal in the 19th century, said there were more temples than houses and more gods than people.

The inhabitants of Nepal are to some extent related to each other, though the population is very mixed, and includes people of Indian extraction. Those of Mongolian descent may have a common link with the Tibetans. The inhabitants of the mountain states of Bhutan, Sikkim and Ladakh are also of Mongolian stock. The early art of Nepal and Tibet was strongly influenced by the classical schools of the Gupta and Pala periods of India. The figurative art of 7th and 8th century Nepal shows almost no Mongolian features, but instead has heavy overtones of Gupta India. In fact, many of these early sculptures are difficult to distinguish from their Indian counterparts. Early Nepalese bronze images, too, are almost entirely Indian in character. Mongolian features did not become apparent until about the 10th century, after which time they became more and more pronounced, until the eyes on many of the later bronze figures are indicated as mere slits.

In Tibet, too, early figurative art reflected Gupta and post-Gupta artistic traits. Tibetan images, like those of Nepal, were modelled on Indian originals and retain a great deal of the early Indian style, even to this day. In Tibet, though, the artistic influences at work were far more complex than those in Nepal, for in addition to the art styles of India and Nepal, Tibetan art was affected by the Buddhist art of China, which was itself influenced by the Greco-Indian and

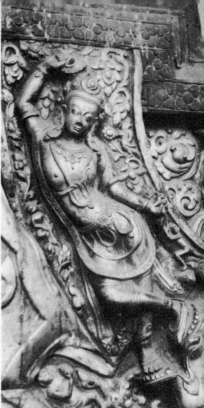

Left: *Buddha sculpture in the precinct of the White Machendranath Temple, Katmandu, Nepal.*
Right: *Detail of the gilt-bronze doorway at the White Machendranath Temple, Katmandu, Nepal.*

Gupta schools. So we have, in effect, direct influence from India by way of Nepal on the one hand and indirect influence, coloured by Chinese thought on the other.

In Nepal and Tibet, art is entirely religious. It was never indulged in for art's sake, but was undertaken almost as an act of worship, certainly it was considered as a way of obtaining spiritual merit, both by the artist and by the sponsor or donor who paid for the work of art to be made. Tibetan art is principally Buddhist, whereas that of Nepal is equally Buddhist and Hindu.

There is a major technical difference between the methods used by Indian craftsmen and those used by the Nepali and Tibetan artisans. The cire perdue or lost wax method of casting bronze images was used by all three countries, but the technique of repoussé metal sculpture is peculiar to Tibet and Nepal. Repoussé is the name applied to the technique of metal-working where the design or form is beaten out of the sheet metal from the reverse side. Images made from repoussé sections were made alongside those created by the more

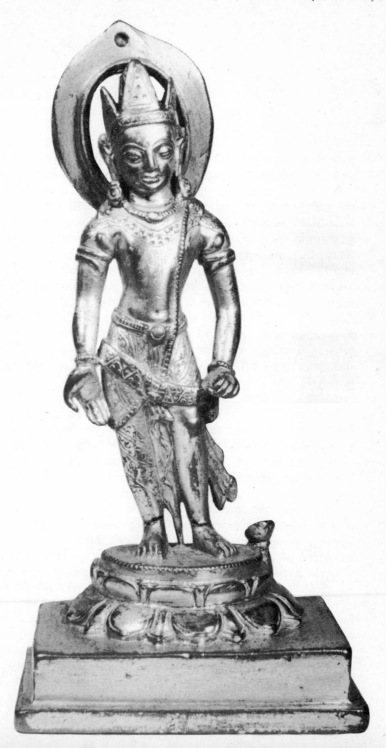

Gilt-bronze figure of Avalokitesvara. Nepal, 14th century A.D.

convenient method of 'lost wax' casting, described in the chapter on Sri Lanka. The repoussé technique was almost an amalgamation of the artist and bronze caster's techniques with those of the copper and goldsmiths. The same craftsmen also made talismans and reliquaries and many other religious objects which they decorated in relief by the repoussé method.

The Buddhist art of Nepal is quite spectacular, for not only have individual bronzes from temples and private altars been preserved and today can be seen in collections throughout the world, but also in Nepal itself large examples of superb bronze and copper artistry can still be seen on temples and in other precincts. The Swayambhunath stupa, just outside Katmandu, preserves some really lovely gilt-bronze figures of the saviouress Tara, together with magnificent relief panels around the shrine. Unfortunately, they are not objects in a museum and are open to the air and the dirt. Thus, their beauty can be hidden beneath grime and vermilion which is smeared on the images as an act of worship. In the same complex is a really superb stone sculpture of Buddha in the *tribhanga* (Broken Curve) position. This statue, which is carved in black stone and dates to the 10th century, is today covered in colourful paint, and it can be quite a shocking experience to realise that underneath the paint is an antique statue. This painting was not done out of irreverence, but just the opposite—the temple is a living entity, and the statue greatly revered, therefore, on the Buddha's birthday it was painted as an act of piety. It is a sobering thought that many sculptures we admire in museums, with their faded colours or worn surfaces, were originally painted in bright colours that we may consider gaudy, however, that was how they were meant to be seen and not as we see them, mere faded echoes.

The whole of the sacred art and architecture of Nepal is living, thus it is constantly being added to, repainted and sometimes repaired, making accurate dating very difficult. Many of the wooden sculptures on the eaves of the temples have been painted a number of times, and when worn have been repaired and replaced, a process which encourages the continuation of archaic forms. In this way, many of the towns of Nepal, especially those that have not been subject to modern intrusion, such as Katmandu, have changed little over the centuries and resemble towns of ancient India. Time in Nepal has simply stood still. A similar situation existed in Tibet, prior to its modernisation under the Chinese. Today, Tibet is as far removed from the culture of ancient times as are other countries in the east, for its ancient religious tradition has been com-

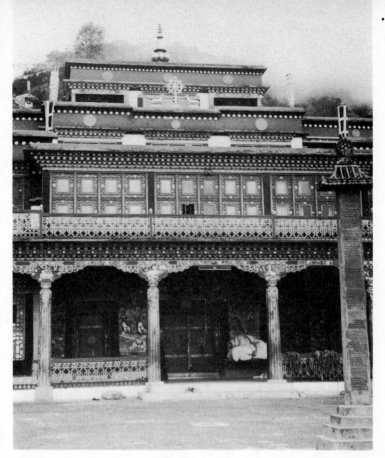

The highly ornate façade of the Rhumtek monastery in Sikkim, the seat of the Gyalwa Karmapa (see page 33).

pletely obliterated. Tibetan culture and Tibetan Buddhism today exists only outside its homeland. It has spread through the agency of its refugee people and their religious teachers to many parts of the world. It is a culture in exile. The Lamas who followed the Dalai Lama into exile are spreading the teachings of Tibetan Buddhism.

Before the introduction of Buddhism into Tibet, the people followed the ancient religion of Bonpo, or Bon. This was a religion based on magic, its rituals combined elements of sorcery and sexual mysticism involving animal and even human sacrifice. Legend has it that it was the Chinese and Nepalese wives of the Tibetan King Srong-san-gan-po, who persuaded the king to embrace Buddhism in the 7th century A.D. Both devout Buddhists, they had brought sacred images with them to Tibet. Legend also credits them with the introduction of the alphabet, which the Tibetans adopted from an Indian prototype brought to Tibet by the Indian Buddhist monks who had been invited there to teach the doctrine. This script was

used in making Tibetan translations of the sacred books. Both wives are revered in Tibetan Buddhism and have assumed the identity of White Tara (Chinese wife) and Green Tara (Nepalese wife).

Gilt-bronze figure of Tara. Nepal, 15th century A.D.

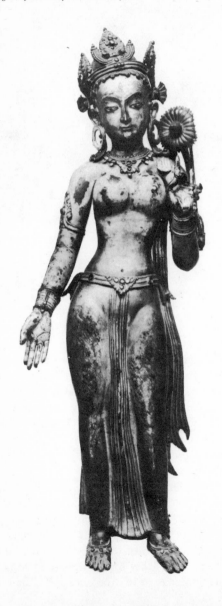

In the early days, Buddhism found it hard to make much progress. Realising this, the Tibetan King Ti-song-de-tsen, sent to Nalanda in India, a centre of Vajrayana Tantric Buddhism, for a teacher to help convert the people. Thus, in A.D. 747, Padmasambhava entered Tibet. He added elements and deities of the indigenous Tibetan Bon to the form of Tantric Buddhism which he had brought with him. The result, what we know today as Lamaism, was extremely successful, and soon took a hold in the country. Padmasambhava is known as the founder of Lamaism and is generally regarded as a saint. He is portrayed on thangkas (painted wall hangings) and in bronze. He founded the Red Cap Order, the Nying-ma-pa. They still teach Tantric Vajrayana doctrines.

Tantric Buddhism was best suited to Tibet as it had more in common with the old indigenous religion, which itself was steeped in ritual and mystery. Tantrism is based on the worship of the *sakti*, or energy of the deity, expressed as female, in conjunction with the male force. In other words the opposite energy field of the male, which, when united with the male becomes the whole and supreme force. As male and female are united by sex, sex plays a major role in ritual. In art, this union between a deity and his *sakti* is depicted as ritual union, and is known as yab-yum. Deities in yab-yum are represented in sculpture as well as in paintings.

In Nepal, Tantrism, both Hindu and Buddhist, gained a strong hold and it is still a very important aspect of religious belief. A large proportion of both paintings and sculpture express Tantric thought, through many-armed and many-headed deities, symbolic manifestations of Tantric doctrine. As sex plays an important part in Tantric ritual, it is openly displayed even on temples. Tantric manifestations are depicted either as benign or beneficent beings, or as horrific monster-like creatures, both are symbolic. Their true use is not to be worshipped, but to be aids to the worshipper in identifying with the deity within, of becoming one with everything, of release and in the knowledge of the true power of identity of self. As we have seen before, the understanding of the Tantra can only be realised by study under a master and by initiation.

Tantrism also played an important part in India. Primitive ideas, magic and sexual mysticism were added to Mahayana Buddhism, the result of which, as we have seen, was the Vehicle of the Thunderbolt, Vajrayana, or, as it is also known, Mantrayana (based on the *mantra*—the ritual formula). Its centre was north-east India, from where it spread to both China and Japan, and though it died out in China, it still survives in Japan as Shingon.

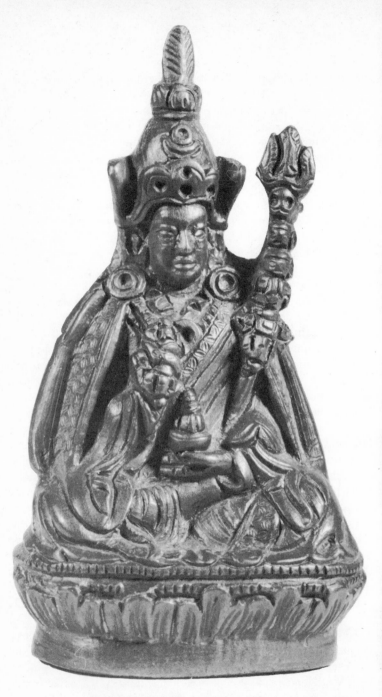

Tibetan bronze figure of Padmasambhava. 19th century.

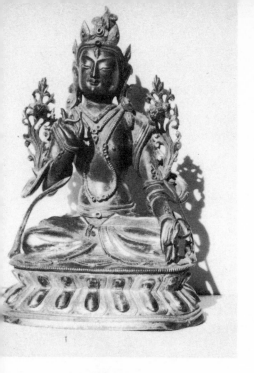

betan jewelled gilt-bronze image of Avalokitesvara.

lt-bronze figure of Tsong-ka-pa. Tibet, 18th century A.D.

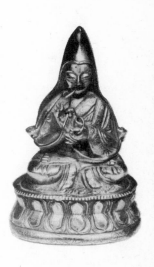

Top: *Crossed vajra seal on the base of a Tibetan image.*
Above: *Tibetan gilt-bronze Lamaistic image, 18th century A.D.*

In the 11th century, fully developed Vajrayana doctrines were brought by Atisa to Tibet from Bihar in India. He founded the Ka-dam-pa Order in 1040, which was later reformed by the teacher Tsong-ka-pa, to become the premier order of Tibet, the Ge-lug-pa or Yellow Cap Order.

Even after the successful establishment of Buddhism in Tibet, there still existed Ponist monasteries, the White Bon, which was similar in respects to Buddhism and the Black Pon, the adepts of which were greatly feared by the people as sorcerers.

Life in Tibet before 1950 was dominated by religion. It was traditional for at least one male child per family to enter an order. Very few women became nuns. In Nepal, religion still dominates, but the Buddhism of Nepal is not Lamaism, though there are Lamaist monasteries and communities. The relationship between the two is cordial, and distinction is not made by the worshippers. In Tibet the Yellow Cap Order was the most popular. It has over three hundred divinities, of which there are numerous variations. For example, there are over one hundred and eight forms of the Bodhisattva Avalokitesvara. There are even more in the Red Cap Order. It will be clear from this that the Buddhist iconography of Tibet is most complex.

Images, together with thangkas (banner paintings) and other sacred objects, played an important part in the religion. No allowance could be made for variation in form or symbolism so there were rigid canons which laid down the images' features and proportions. As a discipline, Lamaism allowed the artist some freedom of expression. This then resulted in great works of art and an image worthy of worship. Many are works of sheer genius, the result of inspiration through meditation. In Tibet, most art was religious, and by virtue of its dominance, Buddhist.

The thangka paintings of Tibet and Nepal are religious works meant for teaching rather than pure decoration, although many that hung in Lamaseries were of great beauty and enhanced the appearance of the buildings in which they were hung. The Tibetan word thangka is derived from the words 'than-yig', meaning 'written record'. This is a very apt description for these paintings, for they are, in fact, records of the teachings of Buddhism (and in Nepal sometimes Hinduism) 'written' in scriptural picture language. They had their origin early in Tibet's history when permanent monasteries were non-existent, and the monks, like the people, were nomadic. Whole monasteries were mobile and the thangka evolved as a kind of mobile fresco.

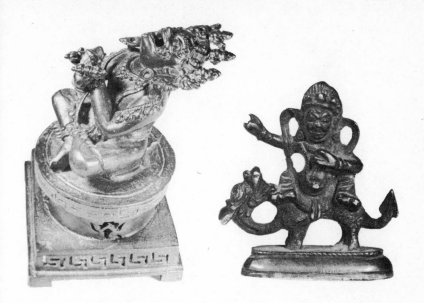

Left: *Tibetan bronze censer in the form of Samantabhadra. 19th century.*
Right: *Miniature bronze figure, probably Sitajambhala. 18th century.*

Although the style of painting is ancient and initially derived from classical Indian sources, the paintings may look extremely old; examples earlier than the 17th century are, in fact, very rare. Thangka paintings are closely related in style to the 10th and 11th century Pala paintings of Bengal in India. Tibetan painting is, in fact, a subtle blend of Chinese and Indian elements. The technique of depicting flowers and trees, mountains, clouds and rivers, owes its inspiration to Chinese art, as it is the treatment of visions or dreams which the Tibetan artist shows as a transparent mist floating in space. Indian influence is seen in the treatment of the figure and costumes and in the arrangement of the deities in the composition.

Images were made for the adornment of temples and also for private shrines. Travelling monks also kept images in small portable shrines. Virtually hundreds of thousands of metal images were made over the centuries, representing deities in different poses and forms. The most common depict the Buddhas—the Manusi Buddhas; i.e. the historical Buddhas of which Sakyamuni is the fourth and which Maitreya is the Buddha to come. The Dhyani Buddhas—the spiritual sons of the Adi Buddha—the primordial Buddha, Creator of the Universe. For those unfamiliar with the intricacies of Tibetan iconography, it would be almost impossible to distinguish between them. Equally popular were the figures of the Bodhisattvas, these include Manjusri, Vajrapani, Avalokitesvara and Maitreya. The Dalai

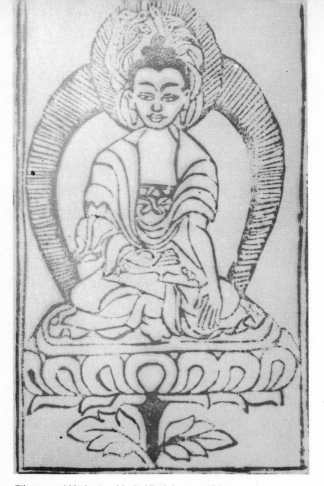

Tibetan wood-block print of the Buddha Sakyamuni. 19th century.

Lama, Gyalwa Rinpoche is believed to be the living incarnation of Avalokitesvara. There are also images of the Dharmapala (defenders of the law of Buddhism), female images of Taras and saktis, as well as incarnations of the great Lamas and Teachers.

In Tibet, the creation of beauty became a form of devotion, to produce a thing of beauty added to one's spiritual merit. For the laity to enter a temple was an aesthetic as well as a spiritual experience. The use of beauty, the richness of colour and precious metals were all intended to glorify the faith. The Buddha once said to Ananda, his disciple, in reply to his statement that one-half of the saintly life is friendship, association, and intimacy with the beautiful, 'Ananda, do not say that, for beauty constitutes the whole of the saintly life. A monk, who does not feel affinity and intimacy with beauty, cannot be expected to follow the Noble Eight-fold Path and

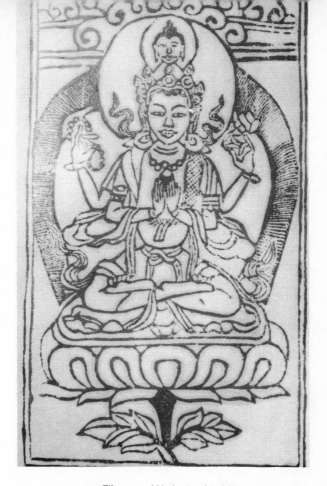

Tibetan wood-block print of Avalokitesvara. 19th century.

to make use of it.'

Because of this connection between religion and beauty, the stress on the quality of art was extremely high. The artist was expected to produce only his best, for nothing but the results of his best efforts would do. Tibetan art cannot, therefore, be simply grouped together as mass-produced 'religious art', for each work, however crude or fine, was a statement of faith and devotion and represented the best effort of the artist. A few extremely talented artists were able to produce works of the highest order within the confines of canonical laws.

Buddhist artistic ideas diffused along the borders of Tibet into China where Lamaseries were established. Buddhist doctrine also reached China by way of Central Asia, and, in fact, Buddhism established itself in China before it took root in Tibet itself.

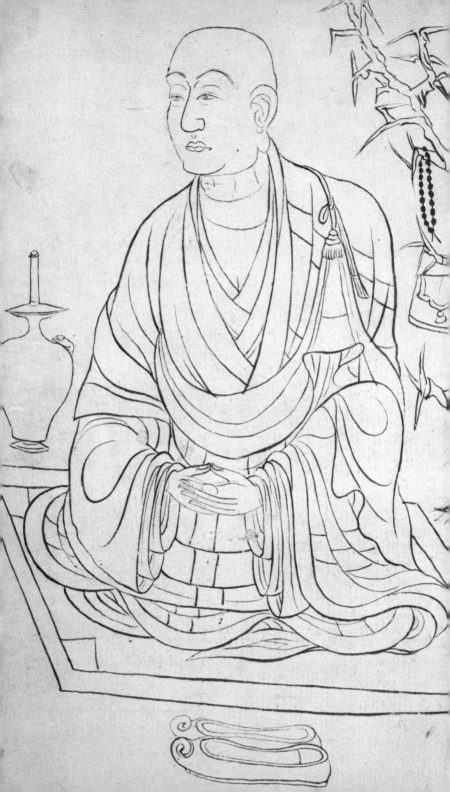

9 CHINA

The history of Buddhism in China is also the story of Buddhist art. In China, however, Buddhism had to fight a completely different battle to establish itself, for unlike the other countries that it had penetrated, it encountered a highly developed and sophisticated culture which in many ways was based on completely different principles. Buddhism was thus faced with a situation that it had not met before. Had it not compromised in the beginning, and incorporated some of the indigenous Taoist ideas into its teachings, it would not have survived. Confucianism was, however, the antithesis of Buddhism, and it was not until about the 4th century that a common ground was established between the two philosophies which enabled the educated upper classes to embrace the teachings of the Enlightened One.

By the first century A.D., during the Han dynasty, Buddhism made its first in-road into the celestial empire. At first it was practised only in small pockets in China, and then principally by foreigners. Later, conversions were made, and it gradually began to spread. Until the 4th century A.D. no Chinese citizens were allowed by order of the Government to become members of the *Sangha*.

The influx of Buddhism into China was on two fronts, the northern front from the north-west borders, where the doctrine was introduced by way of Central Asia, and from the south, where some influence, however slight, was felt by trade through Tongking with

South East Asia. Influence spread southwards from the northern areas towards the centre of the Han empire, Ch'ang-an and Lo-yang, while the southern influence diffused only slightly northwards. This led originally to Buddhist art developing along slightly different lines in north and south China. This continued until from about the middle of the 6th century onwards, when the two areas began to interact with one another and a kind of cross-fertilisation took place, creating in the Sui dynasty a mature Buddhist style which flowered in the classical style of the T'ang dynasty.

In the north, the rather large populations of Chinese people were the first to become Buddhists. They readily accepted the doctrines from their western neighbours. Thus, influences from Gandhara which had made their way northwards from Afghanistan to Central Asia had a major influence on Chinese art of the northern borders, and can clearly be seen at Tun-huang.

In the south, the influence of Amaravati and Gupta centres of Indian Buddhist art travelling by way of Funan, Champa, and Tongking, penetrated China and were absorbed, eventually joining up with northern influence.

Both Hinayana and Mahayana doctrines entered China, existing at first side by side, and later, as in other parts of the Buddhist world, Mahayana doctrines became more popular eventually routing Hinayana.

In the north, it was the Gandhara style of north-west India that in the early days had the most influence on the development of Chinese Buddhist art. Copies of the Gandhara Buddha, in what is known as the Udyana style, were brought to China. Figures in similar decorative styles were also made in Central Asia. Artistic ideas reached China by diffusion and by direct imports. In this way, northern Chinese Buddhist art received direct influence from India, as well as diffused influence from Central Asia. These were grafted on to an already well-developed Chinese indigenous art tradition, thus the early Chinese images, although following Gandhara styles closely, were modelled to suit Chinese tastes.

In addition to the Gandhara model, the Chinese added elements of the Mathura and Sarnath Gupta style, which had also reached China in the form of statues that combined both. When these were merged with Chinese ideas, the result was unique. However, as time passed, the Gandharan elements became less and less discernible. Broad shoulders became narrow and later sagged; the figure lost its volume, became flat, with details carved in relief, while drapery was depicted as stylised geometric patterns.

e: *Chinese painting of Lohans. 16th century.*

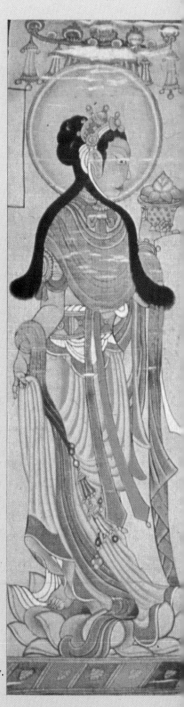

Right: *Painted banner from the caves at Tun-huang.*

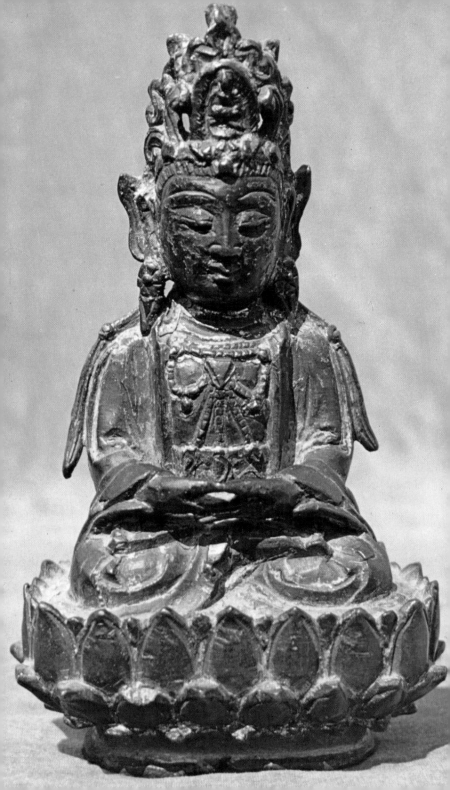

Chinese landscape painting by Ma-yuan (1190–1225).

Chinese painting showing Lohans and a Tantric diety. Ming dynasty.

Opposite: *Chinese bronze figure of a Bodhisattva. 16th century.*

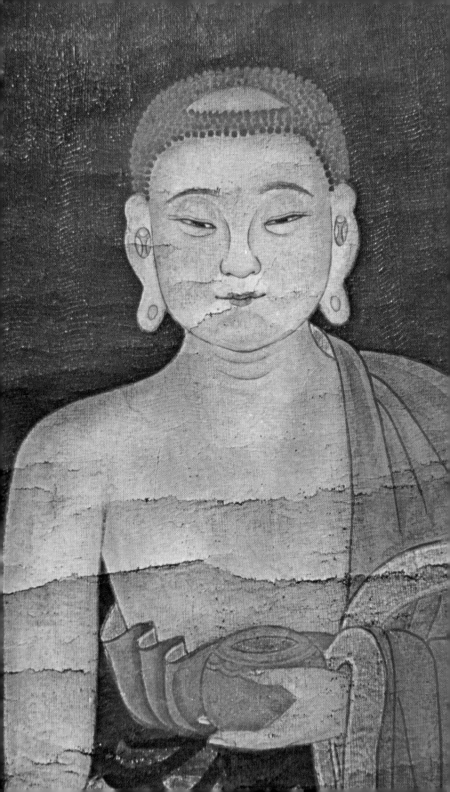

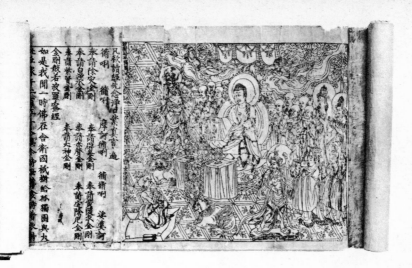

The 'Diamond Sutra'. One of the earliest dated specimens of block printing. Paper roll found at Tun-huang, China. The Sanskrit Buddhist work Vajraschedika prajna paramita in Chinese translation. The Buddha is shown addressing Subhuti, an aged disciple. 9th century.

Some of the earliest dated sculptures are to be found at Yun-kang at Ta-t'ung-fu in Shansi. Monumental figures were carved there out of the living rock of the gorge, echoing in a way the similar practice which was carried out at Bamiyan in Afghanistan. The work seems to have begun in A.D. 460, and continued for thirty-four years, when the Northern Wei capital was moved from Tai (Ta-t'ung) to Lo-yang. The early sculptures at Yun-kang clearly reflected the Gandhara style, but the later ones are in the mature Northern Wei style. Many are dated by the inscriptions. Monumental sculptures continued to be carved after the court moved to Lo-yang, this time in the cliffs at Lung-men; these date from the late 5th to the mid 8th centuries A.D.

The Wei style is noted for its obsession with robes, which are elaborate and fall in two tiers of parallel folds. The figures are elongated and angular, the face is squarish, set on a long neck, the eyes are mere slits with no pupils, and there is an enigmatic smile on the lips. The earliest Buddhist paintings were found in the 'Caves of the Thousand Buddhas', at Tun-huang on the western frontier of China and Central Asia. The frescoes there, dating from the 4th century A.D. provide the first evidence of the impact of Buddhism on the art of China. Situated as they are on a trade route between China and the West, they absorbed foreign influences from an early date. It is not surprising, then, that the influence of Buddhism was felt early in Tun-huang's history.

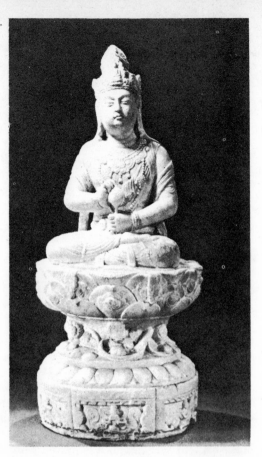

Marble sculpture of Avalokitesvara, Táng dynasty.

Work on the caves is supposed to have begun in the year 366, as a result of a vision which had been revealed to a monk called Lo-tsun. In his vision, Lo-tsun saw one thousand Buddhas appearing over the mountain-tops of Tun-huang.

Excavation on the caves was started, and in a comparatively short time, hundreds were carved out of the soft limestone and decorated with frescoes, and as the rock was not suitable for sculpture, painted statues of clay were included in their stead. In the 7th century, it is said, there were more than a thousand caves, but present-day surveys have shown that this was an exaggeration, the number being only four hundred and eighty-six. They are tremendously important, as they preserve numerous frescoes, which are masterpieces of Buddhist art. History has left its mark on Tun-huang, as major events have all left some trace in one way or another on the art preserved there. From A.D. 777 until 848, Tun-huang came under the protection of Tibet, in spite of political interruptions, it continued to be a religious centre, producing Buddhist works of art until the 14th century.

One of the earliest dated Chinese bronze images known to us is a gilt-bronze seated figure of the Buddha dated 338. Now in the Avery Brundage Collection, in the M. H. de Young Memorial Museum, San Francisco, it has stylistic elements very similar to Central Asian prototypes on which it seems to have been modelled. Both large and small bronzes seem to have been produced, but most of the larger pieces have not survived the passage of time. The largest image that has been preserved is the massive figure of Kuan-yin at the Lung-hsing Temple at Cheng-ting. Made in the 10th century, it is approximately 46 feet high—a triumph of bronze-casting.

Another early figure, dated A.D. 477, which displays Gandharan influences, is the fine figure of the Buddha Maitreya in the Metropolitan Museum of Art, New York. There is also a superb bronze figure of the Bodhisattva Avalokitesvara in the Fuji Museum, Kyoto.

The peculiarity of the development of the style which appeared during the 6th century during the Northern Wei period, was a tendency to accentuate and stylise the robe to such an extent that it flowed outwards in layers like a Christmas tree. Various deities were portrayed including Sakyamuni, Maitreya and Bodhisattvas.

During the Northern Chi (A.D. 550–577), and the Northern Chou (A.D. 557–581) dynasties, the style became more clear cut. Buddha images of these periods have pendulous ears, sculptural linear arms, and the hair is simply shaped, not waved. The flowering lotus position is also seen. At the end of the Wei dynasty, there was a complete change in style, with figures becoming more linear and plastic, the result of renewed influence from India. During the Sui dynasty, the figures are more symmetrical, faces become rounder, and the coiffure of the Buddha is normally shown as a mass of tight curls.

Figures of the T'ang dynasty (A.D. 618–907) have a distinctive style, dissimilar to those of the earlier periods. Also influenced by Indian iconographic ideas, the style has the typical 'Chinese look' of the T'ang period. This is particularly evident in bronze. Images tend to be somewhat formal, with rounded faces, thick lips, slit, curved, almond-shaped eyes sometimes with heavy lids, and bow-shaped brows, sometimes shaped with the line of the nose. The diaphanous, flowing robes have Indian overtones. The overall effect is one of spiritual serenity. Figures of Amitabha were very popular, reflecting the growing popularity of the Pure Land School of Buddhism.

This non-intellectual form of Buddhism necessitated the complete and unquestioning faith of the believer in Amitabha. By calling on him by name, the pious believed they would be reborn in the Pure

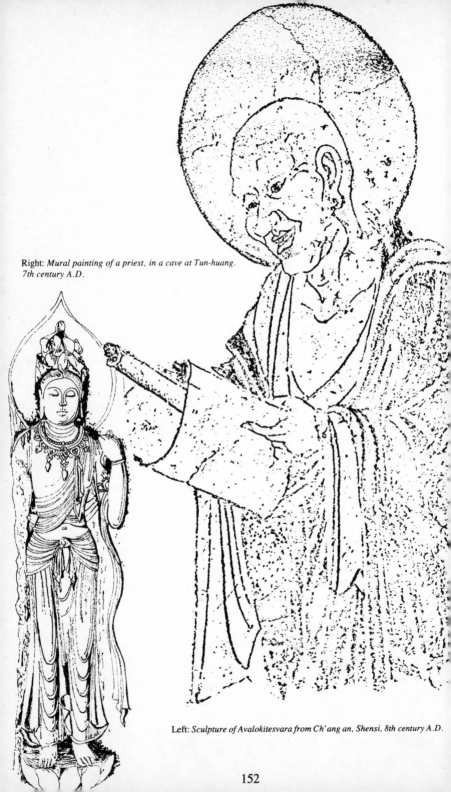

Right: *Mural painting of a priest, in a cave at Tun-huang.*
7th century A.D.

Left: *Sculpture of Avalokitesvara from Ch'ang an, Shensi, 8th century A.D.*

152

Land of Amitabha and be under his protection. This blind trust contrasts strongly with the doctrine of the Ch'an, which was gradually building its foundation at this time; Bodhidharma having entered China in the late 6th century. Ch'an was the very antithesis of Pure Land Buddhism.

At Tun-huang during the T'ang dynasty, we see an art with mixed elements from India, Iran and China, fully integrated into an harmonious pictorial art form. The idea of space became more pronounced, and compositions larger and more involved. The motifs were influenced by Tibetan and Indian ideas of Mahayana Buddhism. Some fine banner paintings and wood block prints, dating to the T'ang period and later, have been found at Tun-huang and provide us with a further insight into the Buddhist art of the period.

In painting, both in China and Japan, we have a sophisticated art form unlike anything that developed in India, Tibet, or South East Asia, for from the T'ang dynasty onwards, paintings are sophisticated works of art produced in the main by educated and cultured men. In many cases they are signed and sealed. We therefore see that Buddhism gave birth to a vigorous art and craft movement responsible for images, temple decoration, architecture, etc., produced by largely anonymous craftsmen as well as a sophisticated pictorial art, deliberately executed for beauty's sake or philosophical comment, and in no way anonymous.

The middle T'ang produced perhaps the greatest artist of the period, Wu Tao-tzu. One of the first professional painters of merit, he worked at the court of the Emperor Ming Huang in the 8th century, although there are few paintings that can be attributed to him with certainty, there are a few that perhaps have just claims, but these are in Japan. The Tofoku-ji at Nara has a fine painting of the 'Buddha Trinity'. Besides scroll painting, Wu Tao-tzu was a master of the art of fresco, and it is said that he painted over three hundred Buddhist murals in the temples at Lo-lang and Ch'ang an, all of which have perished.

During the T'ang dynasty, the art of the Chinese sculptor reached its zenith. The Indian Gupta style affected the development of the art, but the Chinese indigenous style is a dominant factor. The figures are less rigid than those in the preceding period, and although they conform to iconographic canons, there appears to be more individuality. During the latter part of the period, much attention was paid to the form of the Buddha rather than to contrive decorative designs formed by the drapery. The effect is more sensuous. The lofty aspirations of the T'ang sculptors produced works of great

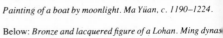

Painting of a boat by moonlight. Ma Yüan, c. 1190–1224.

Below: *Bronze and lacquered figure of a Lohan. Ming dynas*

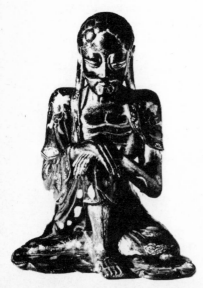

physical beauty. Spiritual beauty was expressed in physical terms.

Political changes sometimes had a drastic effect on sculpture. The most obvious of these were the persecutions of Buddhists which occurred at various times, with perhaps the most savage taking place under the Emperor Wu Tsung in A.D. 845. Over forty-five thousand temples were destroyed and about two hundred and seventy-five thousand monks and nuns were obliged to leave the order.

Change in fashion of Buddhist doctrines also forced change in artistic trends. Ch'an Buddhism (Zen), with its emphasis on instant Enlightenment and dislike of ritual trappings caused the decline in demand for images and an increased demand for paintings. Ch'an had a profound effect on the art of the Sung dynasty, for it had an influence on the subjects chosen for painting. Iconography was out. The essential element in the style was outward simplicity and speed of execution. This produced outlines of spontaneous ingenuity, using subjects from all aspects of nature. The concept that the truth of Enlightenment could be found in even the most humble subject produced paintings of unusual simplicity, which emit an air of spiritual truth.

The appearance of simplicity is misleading, for it is sometimes the result of much thought and meditation. The greatest exponent of the art was a monk called Mu-ch'i (1180–1250). His painting of 'Six Persimmons' is in the Daitoku-ju, Kyoto. It is said that he sat for two years contemplating the blank paper, and then with a few deft strokes, completed the painting in minutes. Most Ch'an paintings are in Japan, where they were more appreciated and where Zen Buddhism is still practised.

The great atmospheric paintings of landscape and nature owe much to Ch'an for their inspiration for they depict a view of nature in which man participates, but does not dominate. Paintings by the great master Ma-yuan, Mu-ch'i, Hsia-kuei, and Liang-k'ai have never been surpassed. They have an air of emptiness, of unpainted area which suggests but does not direct. It was, in effect, painting by not painting—creating out of a void a balance in which the figure, if present, is an integral part. It was at the same time something and nothing.

Mu-ch'i and Liang-k'ai also painted the patriarchs and Ch'an masters, not with reverence as one unfamiliar with Ch'an concepts might expect, but as gay, abandoned madmen, roaring with laughter, scowling, stamping, or engaging in other seemingly ridiculous activities. Ch'an art—Ch'an humour.

Buddhist sculpture of the Sung dynasty is mainly of wood and

lacquer. Figures are naturalistic and more pictorial. Sculptures of Bodhisattva Kuan-yin were popular and a number of large figures are known, some life-size, many of which are in museums throughout the world. The modelling is powerful, contrasting with the drapery which falls in graceful folds. Bronze figures of the period are comparatively rare. Like the wooden figures, the anatomy is much heavier and more solid than in the preceding styles.

Chinese painting of Buddha. 18th century.

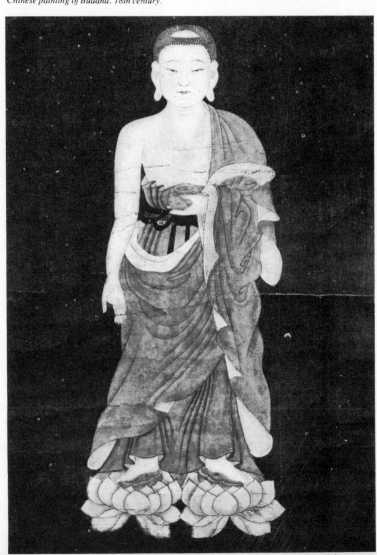

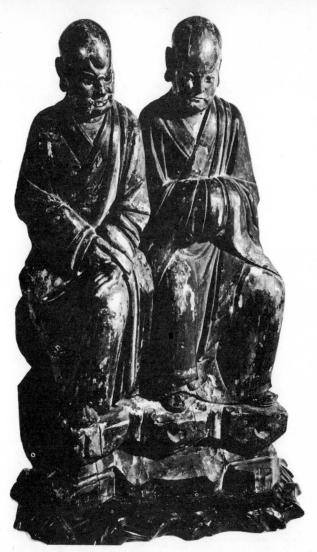

Two Lohans. Wood sculpture of the 16th–17th century.

During the succeeding Yuan dynasty, influence from India, Nepal and Tibet was very strong. Both Indian and Nepalese artists worked in China; we know, for instance, that in the 13th century Ar-ni-ko, a Nepalese artist, painter, sculptor, and architect, was invited to the court of the Chinese Emperor Kublai Khan. He had already created a number of fine works in Tibet; there was, therefore, a great diffusion of ideas at this time. The dynasty itself was Mongol and had come from outside China. Buddhism received a new impetus in the land when it was made the official religion. Images were made in Lamaistic forms, influenced by Tibetan and Nepalese models, a practice that was to continue into the Ming dynasty.

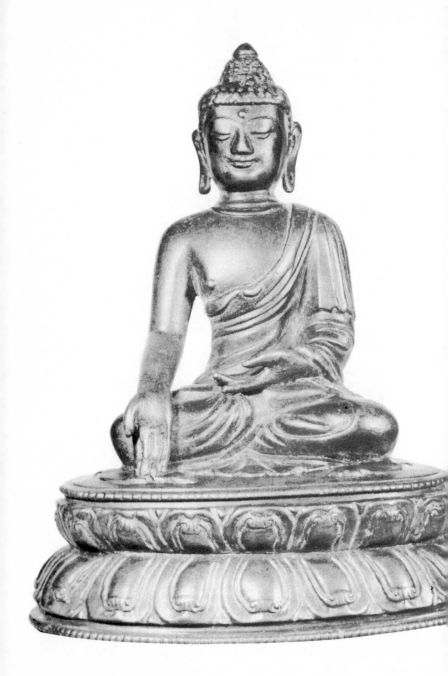

Sino-Tibetan bronze figure of Sakyamuni Buddha. 18th century.

From the Sung dynasty, there existed a style of iconographic painting which was used for the portrayal of Mahayana Buddhist subjects, including Bodhisattvas, Buddha Sakyamuni, Lohans (arhats), etc. Although conforming to canonical prescription, the really great artists managed to overcome these difficulties and produced paintings of really fine quality. Earlier, Tantric subjects had been painted for the Mi Tsung or 'secret school' which flourished during the 8th and 9th centuries. Elements of Tantrism were also incorporated into Tien T'ai school and, of course, formed a part of Lamaism which was especially popular in the border areas of China and Tibet.

Buddhist painting of the Ming dynasty tends to be somewhat stiff, though this is a gross generalisation. Bronzes had to be icons in the purest sense of the word. The influence of Tibetan Buddhism and Tantric doctrines can be seen in the multi-limbed and headed figures. They have an air of formality which occasionally makes them appear rigid, but which is softened by a sublime smile. A number of Lamaist monasteries existed in China, and Lamaist bronzes are sometimes difficult to distinguish from the Tibetan, particularly as some have Tibetan inscriptions.

Buddhism continued to provide inspiration to painters, even after the end of the Chinese Ming dynasty and its replacement by the non-Chinese Manchu Ch'ing dynasty. Artists looked backwards for models, and tradition re-asserted itself with a great show of conservative, nationalistic spirit. The Manchus became even more Chinese than the Chinese!

Buddhist priests, 'individualists', worked in Ch'an style. Their paintings were notable for their originality and spontaneity. The pictures seem to explode on the paper. Only the essentials are recorded, space playing an important role.

Chu-ta (1625-1700), also known as Pa-ta-shan-jen, painted a number of flower and bird paintings, which are masterpieces of simplicity and beauty. Another priest, Tao-chi (1630-1714), is noted for the swiftness of his brush, best seen in his landscapes. K'un-ts'an (1625-1700), another member of the priesthood, painted Buddhist subjects, but in a different way to traditional renderings.

After the end of the Ming period, Buddhist bronzes continued to be made but tended to be somewhat iconomatic, lacking the inspiration of the great days of the blossoming of the doctrine in the land. Although the flower of Buddhism has withered and died in China since the Revolution, its offspring, its religious art and elements of its teachings still flourish in Japan.

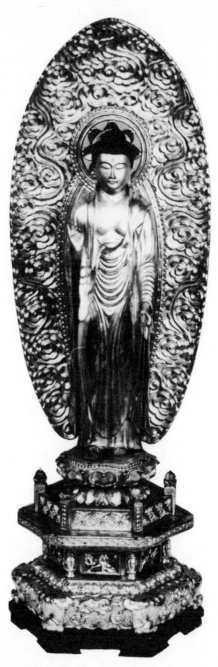

Japanese gold lacquered wood figure of Buddha. 18th century.

10 JAPAN

Buddhism arrived in Japan by way of Korea in the 6th century A.D. Like the introduction of Buddhism into China, which was accompanied by foreign monks who brought with them their religious art, the first bronze images in Japan were of foreign origin, brought by the mission from Korea in A.D. 552. It is recorded that the mission was followed in 557 by an artist versed in the art of image making. It is not surprising, therefore, that the first Japanese bronzes should be influenced by the Chinese artistic trends which themselves reflected, as we have seen, influences from India and other countries. The first representation of the Buddha found in Japan, however, occurs much earlier, on a Chinese bronze mirror dating to the 3rd century. It was found near the ancient capital of Nara.

Buddhism had become firmly established by A.D. 604 and had received state recognition. It was during this period that the famous Horyu-ji Temple was built at Nara, thus, in only a few short years, Buddhism had put down the roots of one of the strongest trees of Buddhist culture. The man responsible for this was Prince Shōtoku (574–622), who overcame strong resistance from the followers of the nature cult of Shinto. Because of Japan's conservative nature, and because it is today an open country where Buddhism has flourished for over 1,400 years, we are fortunate to have an almost continuous record of her Buddhist art treasures. Many of these are housed in temples and temple store-houses, others are in Japanese museums,

or in the Imperial collections, while yet others have left the country and are in museums and private collections all over the world.

The earliest dated Japanese Buddhist bronze is a figure of the Buddha in the Angu-in, near Nara. It is, however, badly damaged and another image, the Yakushi Buddha at Horyu-ji dated 607, gives a better idea of the bronze art of the period. It was originally the principal image at the Temple. A bronze group, the 'Shaka Triad' also at Horyu-ji, bore the inscription stating that the figures were made in the year A.D. 623 by Shiba Tori, whose grandfather was a Korean immigrant. It shows strong affinity with Chinese and Korean models. The group, which is extremely interesting stylistically, consists of a central figure of Sakyamuni (Shaka) and two attendant Bodhisattva figures. The whole effect of the modelling and composition is abstract, reflecting the transcendental spiritual aspect of the image. One of the most striking points about the group is the obsession with drapery, which seems to flow everywhere, settling in tiered folds, an echo of the Chinese Northern Wei tradition.

The Horyu-ji Temple at Nara is the oldest Buddhist temple, not only in Japan, but also in the whole of East Asia. Founded in A.D. 607, it contains countless treasures of early Japanese Buddhist art. Japan, in fact, contains more examples of Buddhist art of this period than have survived in China and Korea. It is a vital store-house of East Asian art and culture. Thus, in some ways, it mirrors a now lost art. In the early Japanese styles, we see elements of Chinese, Korean, Central Asian, West Asian and Indian influences quite clearly. All these influences were retained over the centuries but bear the distinct stamp of Japanese indigenous artistic ideas. Nevertheless, in many cases we can learn more about the missing elements of art, music, dancing and drama from Japan than from the original source.

The early Buddhist two-dimensional art of Japan was strongly influenced by Chinese trends, for after initial contact had been made with Chinese cultural and artistic concepts through the intermediary of Korea, direct contact with China was established, thereby opening the flood-gates to Chinese cultural ideas in all forms. The first Buddhist paintings in Japan are probably the work of Chinese or Korean painters. Even the famous shrine of Tamamushi at Horyu-ji, with its scenes from the *Jatakas*, may be the work of a Korean artist. Unlike most Chinese and Japanese painting, the panels of the shrine are painted with oils.

During the Nara period, A.D. 710–794, Chinese influence was very great indeed. Strongly affected by the wondrous city of Ch'ang an, the Japanese produced their own miniature version, the city of

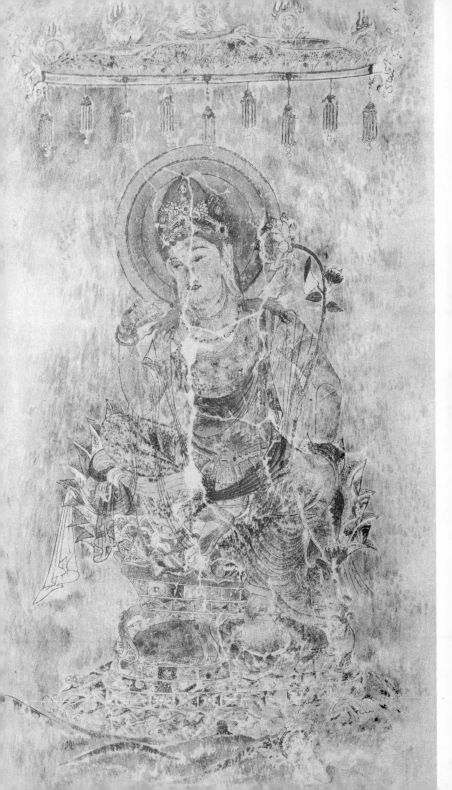

Nara. Special Imperial Departments were established to encourage the arts with the result that the Japanese learned the lesson of their Chinese model so well that it is often difficult to distinguish between the paintings of the two countries at this period. Unfortunately, one of the finest examples of painting of the Nara period, the fine murals in the Kondo at Horyu-ji, were devastated by fire in 1949. Now, all that remains is a faded outline and some excellent colour photographs taken by a Japanese photographer shortly before the tragedy. The murals were extremely beautiful; figures of Buddhas, Bodhisattvas and celestial beings were painted in quiet and reserved colours on the four walls, giving an overall effect not only of grandeur but also of serenity and peace of mind. These fine paintings, dating to the beginning of the 8th century, were among the masterpieces of Buddhist art. Both in technique and subject, they can be compared with the mural paintings of India, such as those of Ajanta, though here the figures are fuller, more abstract and monumental than those of the more plastic Indian prototype. The anatomical outline of the figures were beautifully drawn with even iron-red flowing lines and coloured with brown, yellow, blue, red and green pigments. Shading was sparingly used to give the figures only a suggestion of substance.

As with the painting, sculpture in metal, clay, and dry lacquer, followed the T'ang style. The massive bronze statue of Vairocana Buddha at Todai-ji was cast at this time. Fifty-three feet high, it required approximately a million pounds of metal to cast it, and about five hundred pounds of gold to gild it. After a number of failures it was completed in the year 749.

In complete contrast is the miniature shrine of Lady Tachibana in the Kondo at Horyu-ji. Consisting of a central figure of Amida (Amitabha) Buddha, flanked at either side by attendant Bodhisattvas, treatment of the figures is far more sensuous than those of the preceding period. The beautiful central figure of Amida has Indian Gupta overtones, coloured by Chinese artistic trends.

During the Nara period, physical beauty and spiritual beauty were regarded as synonymous. The finest bronze of the period is the Gakko Bosatsu, the Moonlight Bodhisattva, one of the attendant figures of a trinity made about the year 720. This beautiful, larger-than-life figure has a serene facial expression with a sensuous treatment of the body, which is bent in a gradual obtuse figure S. The gilding has worn off, revealing the warm tones of the bronze. Although the figure shows all the main points of T'ang sculpture, no known comparable statue exists in China. Sculpture at this time

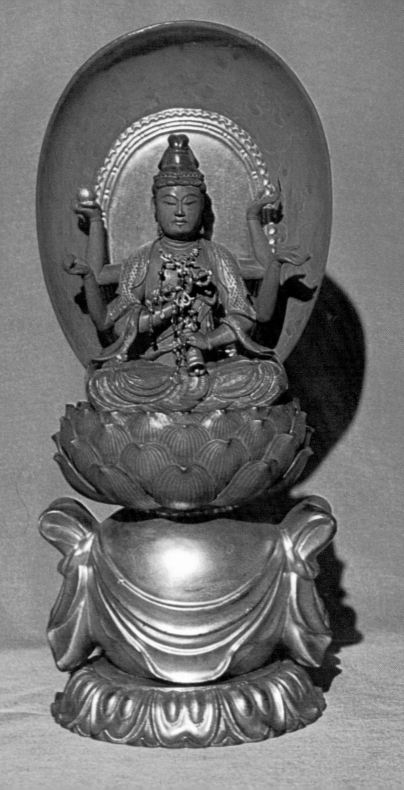

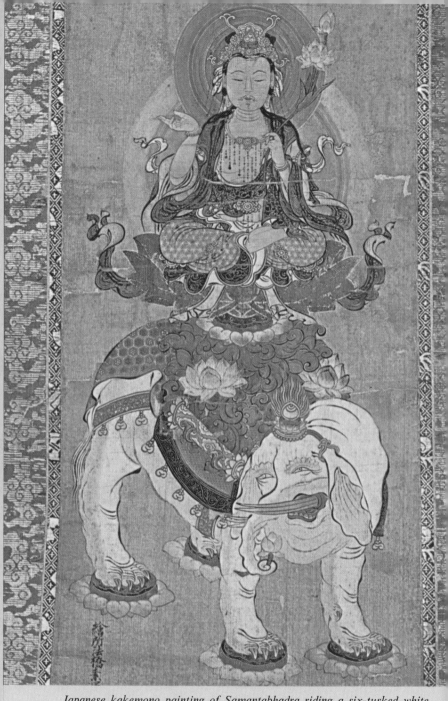

Japanese kakemono painting of Samantabhadra riding a six-tusked white elephant. 18/19th century.

Overleaf: *Painted and lacquered figure of Vajrasattva. Japan, 19th century.*

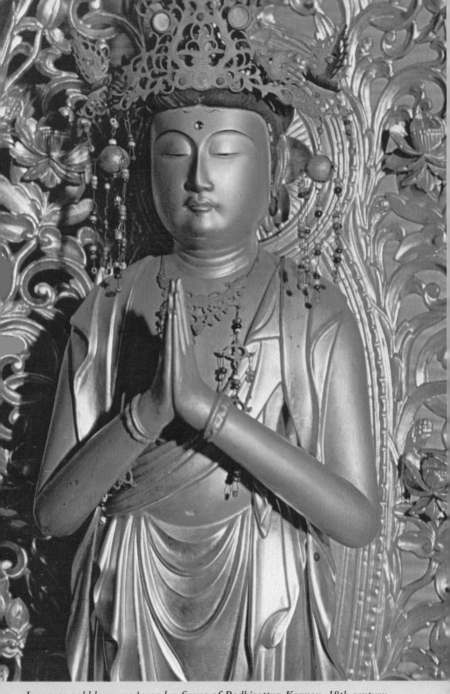

Japanese gold lacquered wooden figure of Bodhisattva Kannon. 18th century.

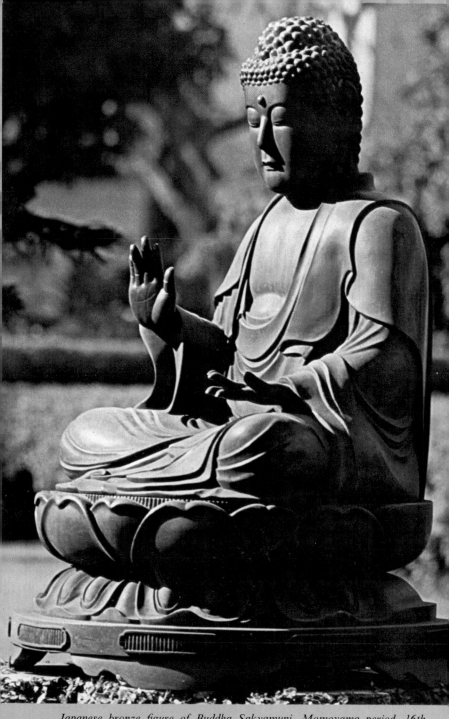

Japanese bronze figure of Buddha Sakyamuni. Momoyama period, 16th century.

tended to be of clay, on a wooden framework, the finest work in this medium being the Nikko Bosatsu, the Sunlight Bodhisattva, in the Todai-ji Temple at Nara. This, too, reflects the T'ang style.

At the beginning of the Early Heian period (794–897), the capital was moved to what is today Kyoto. A number of new sects of Buddhism were introduced at this time, which had a profound effect on the art. In A.D. 805, Tendai was introduced by Dengyo Daishi, while Shingon was founded by Kobo Daishi, a year or so later, on his return from China in A.D. 806/7 with the 'True Word'. Thus, the simplicity of the early Buddhist art of Nara was superseded by an art strongly influenced by the more elaborate iconography of later forms of Mahayana Buddhism.

Part of the ritual of Shingon was secret and only revealed to initiates, but salvation was made easy for the layman, who only had to chant the public 'magic' formulae and not be troubled by the more mysterious and esoteric beliefs. The fearful and aweful aspects of the doctrine were emphasised in paintings and sculpture.

A form of painting also seen in Nepal and Tibet (and in China in the Mi Tsung or Chen-yen sect), the *mandala*, or in Japanese, the *mandara*, became popular. This was a magic 'geometric diagram' used to express the complexities of Existence, as seen by the Tendai and Shingon faiths. Used in special rituals, they were devised according to instructions recorded in the twenty-two volumes of the *Tantra*. *Mandaras* are of more interest for their fine execution and draftsmanship than for their artistic merit.

The art of Shingon Buddhism was severely restricted by iconographic canons, but Japanese artists overcame these difficulties far better than those of other countries who embraced *Tantric* beliefs. The true impact of Shingon can be seen in the somewhat horrific subjects chosen. Figures are sometimes endowed with a glaring expression, many arms, fangs, and are surrounded by flames. The impact of esoteric Buddhism on sculpture can also be seen in images of fantastic forms with numerous heads and arms.

Under the Shingon and Tendai, the gods of Shinto, the indigenous cult of ancestors and natural forces, were incorporated into the pantheon as manifestations, thus ending in an amiable way a conflict that had existed between Shinto and Buddhism from the latter's introduction into Japan.

By the Heian period proper, also known as the Fujiwara period (A.D. 897–1185), esoteric Buddhism had lost much of its attraction, although the old Nara sects continued. The sect of Jodo became popular. This simple form of Buddhism is devoted to the worship

智照无二相知
識普門国再
見文殊師利菩
薩讚
尒時摩頂手長舒
百十由旬栢堰逢
晚覓善財如所住
普門何處見文殊

Segment of the handscroll of Kegon Gojugo-sho Emaki, 'The Fifty Five Places of the Kegon Sect', a Buddhist work of the late 12th century. The illustration shows the boy Zenzai Doji before Manjusri.

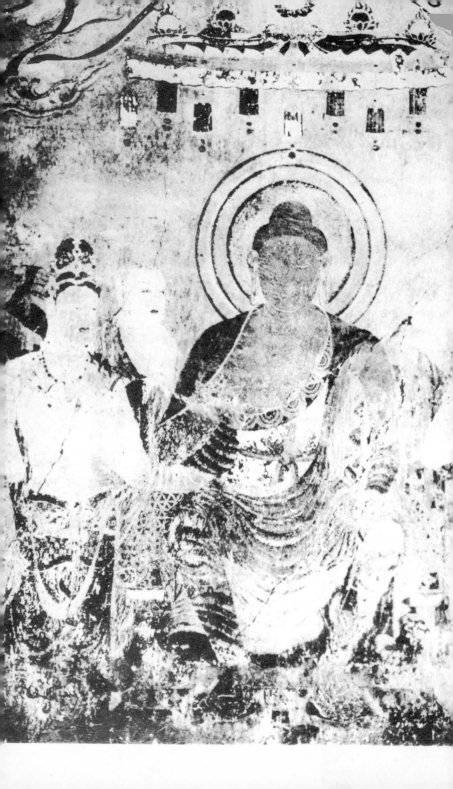

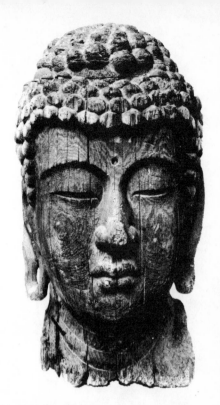

Head of Amida Buddha. Wood, Japan, late 12th century.

Left: *One of the murals in the Kondo at Horyu-ji which were devastated by fire in 1949. 8th century A.D.*

of Amida Buddha, Lord of Boundless Light. First introduced early in the Nara period, it did not become really popular until the Heian. Salvation was made easy; one had only to recite the formula 'Namu Amida Butsu', and the road to paradise was secure and re-birth in the 'Pure Land' would be assured.

The change in popularity of Buddhist doctrine was reflected in art. Paintings, bronzes and sculptures of Amida were made in various positions. Painting became quieter and more realistic, and even the Shingon and Tendai sects found it necessary to introduce more benign, powerful and attractive renditions of deities in order to retain their popularity with the people.

The warm colour and naturalistic charms of Jodo paintings placed them among the finest examples of Japanese religious art. A popular composition showed Amida surrounded by his attendants, descending from his heaven to receive his followers. Known as the Amida Raigo, it continued to be a popular subject in Japanese Buddhist art.

Images of the time tend to be effeminate, lacking the force and

presence of those of the Nara period. Perhaps the finest piece of art glorifying Amida is the 'Phoenix Hall' at Uji near Kyoto. The entire temple is dedicated to Amida and depicts him in his palace in the 'Pure Land' on earth. The central statue is by Jocho, a master sculptor. The walls were beautifully painted with the Raigo, but unfortunately have been damaged.

What can be described as the most spectacular figure of Amida is the gigantic figure of the Kotoku-in in Kamakura, and is certainly

The Daibutsu (Giant Buddha) at Kamakura. 13th century A.D.

the most famous work of the time. Cast in the 13th century, it was originally housed in the main hall of the temple, but has remained in the open since the wooden structure was destroyed by a tidal wave in 1495. Approximately forty-two feet high, cast in several sections, it is a masterpiece not only of contemporary bronze technology but also of artistic skill. Despite its huge size, it is modelled with vigour while the details are still as delicate and tasteful as on a smaller sculpture. The proportion and balance is superb.

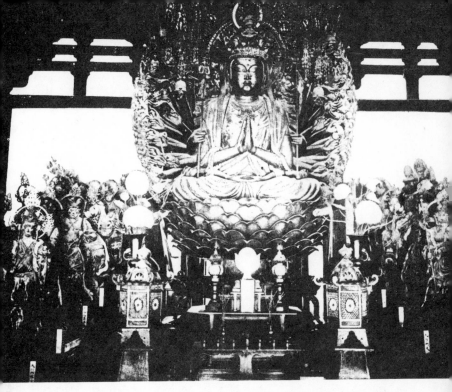

One of the 1000 images of Kannon at the San-ju-san-gen-do at Kyoto. 13th century.

Traditional Buddhist painting continued during the Kamakura period and while ideals of Zen Buddhism influenced some of the art it is mainly in the succeeding Ashikaga period (1392–1573) that its full impact was felt. The rise in popularity of Zen was accompanied by a decline of the iconographic sects and other art.

Buddhist bronze figures were made during the Ashikaga and Momoyama periods, but they are rigid, iconomatic, and few in number. The last period in which large brass and bronze figures were made was in the early 17th century under the Tokugawa Shogunate, when in an effort to suppress Christianity, the second Shogun, Hidetada, issued an edict instructing each household to have a Buddhist image.

The steady rise in the popularity of Zen thought in the 14th century was reflected in painting as artists inspired by its teachings tried to convey the message of Zen through their work. They were strongly influenced by Chinese Ch'an painting and techniques. Many artists of the period were in fact Zen monks. Apart from a short time during the latter part of the Tokugawa period, the Zen paintings of the Ashikaga and Muromachi period were the last great expression of Buddhist art in Japan.

175

Favourite figurative subjects were hermits, arhats such as Hotei, and portraits of Zen patriarchs such as Bodhidharma. The 14th-century artist Kao's portrait of the Chinese Zen monk illustrates this abandoned style. The pot-bellied figure is shown with a mop of ruffled hair, looking unconcernedly into space. There is not a trace of reverence, only complete naturalism. The brushwork is extremely simple, the picture consisting only of inkwash and a few flowing lines. Liang K'ai and Mu-ch'i had painted similar portraits of patriarchs in China during the Sung dynasty.

Zen attitudes were also admirably expressed in atmospheric paintings of landscapes principally in sumi-e ink and wash. In China, Ch'an had inspired similar paintings during the Sung dynasty, indeed the art of ink-wash painting may even have been perfected in China as early as the T'ang dynasty, although it did not come into general use until later. It was essentially a development of calligraphy, a calligraphic style of painting, a style in which bold outlines were made with rough brushes, the stray hairs of which created lines of controlled accident. Everything is depicted by powerful strokes with rough brushes. The lines avoid regular or geometric shapes, everything suggests itself. It is what has been termed 'the art of artlessness'. The brush paints the picture not the artist; he simply holds the brush!

A master of sumi-e landscapes, perhaps the greatest that Japan produced, was Sesshu (1420–1506). He was one of the first Japanese artists to recognise the beauty of his own countryside, and translate it into painting instead of basing his work on Chinese models. He painted what may be said to be his greatest work in 1486 at the age of sixty-six—a landscape scroll. This measures some 15·25 metres long, and portrays the countryside in different seasons. His technique, a development of the Chinese, produced a unique effect by thickening and accentuating lines. His spontaneous style is masterly. In just a few explosive strokes, he could create a landscape with misty mountains, hut, trees and water. His style was further developed by Sesson (1504–1589).

The influence of Zen declined towards the end of the Ashikaga period but re-asserted itself in, or towards the beginning of, the 17th century when a new expression of sumi-e developed, the Haiga or 'off-hand' style. It is rough, explosive, artless and at the same time a perfect insight into the meaninglessness of nature.

Buddhist paintings in all the styles mentioned continued to be made throughout the Tokugawa period, but generally lacked the originality of earlier works. Buddhist painting, especially Zen paint-

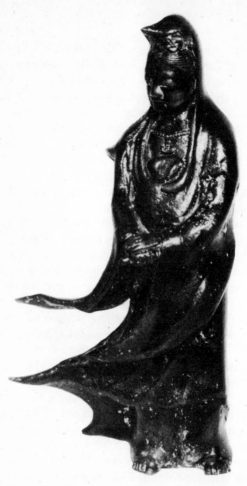

Bronze figure of Kannon. This little figure has a fine sense of movement imparted by the flowing robes. 18th century.

Right: *Zen painting of Bodhidharma the first patriach of Ch' an (Zen) Buddhism. The work of Sesshu.*

ing, has today received new impetus, with an ever-increasing interest in Zen and other forms of Buddhism throughout the world. In addition to those works intentionally executed in the spirit of Zen, there are works of art and literature in many parts of the world that are themselves Zen, for Zen art is natural, it is non-art, which through the unexpected gives us, even momentarily, an insight into life and ourselves. Buddhism, too, has much for the modern world. It is one of the oldest philosophies, but by virtue of its infinite capacity for adaptability and non-belligerence, has survived the passage of time and geography to help man help himself.

178

INDEX

Acknowledgements. *The publishers gratefully acknowledge the following for their co-operation and for permission to reproduce illustrations: The British Museum, London; The Victoria and Albert Museum, London; The Russell-Cotes Museum, Bournemouth; The Imperial Collections, Japan; The National Museum, Delhi; The Archaeological Survey of India; The Indian Museum, Calcutta; Origination Picture and Photo Library, Bournemouth.*
The Archaeological Department and the National Museums of Sri Lanka;